Fun Food for Cool Cooks

Peanut Butter
∽ AND ∽
Jelly Sushi

AND OTHER PARTY RECIPES

by Kristi Johnson

Capstone
press

Mankato, Minnesota

Snap Books are published by Capstone Press,
151 Good Counsel Drive, P.O. Box 669, Mankato, Minnesota 56002.
www.capstonepress.com

Library of Congress Cataloging-in-Publication Data
Johnson, Kristi.
 Peanut butter and jelly sushi and other party recipes / by Kristi Johnson.
 p. cm. — (Snap books. Fun food for cool cooks)
 Summary: "Provides fun and unique recipes for appetizers, desserts, and beverages that can be served
at parties. Includes easy instructions and a helpful tools glossary with photos" — Provided by publisher.
 Includes bibliographical references and index.
 ISBN-13: 978-1-4296-1340-8 (hardcover)
 ISBN-10: 1-4296-1340-8 (hardcover)
 1. Cookery — Juvenile literature. 2. Children's parties — Juvenile literature. I. Title. II. Series.
TX652.5.J624 2008
641.5 — dc22
 2007028295

Editors: Christine Peterson and Becky Viaene
Designer: Juliette Peters
Photo Stylist: Kelly Garvin

Photo Credits:
All principle photography in this book by Capstone Press/Karon Dubke
Capstone Press/TJ Thoraldson Digital Photography, cooking utensils (all)
Tami Johnson, 32

1 2 3 4 5 6 13 12 11 10 09 08

TABLE OF CONTENTS

INTRODUCTION

SEEING STARS

When choosing a recipe, let the stars be your guide! Just follow this chart to find recipes that fit your cooking comfort level.

EASY: ★ ☆ ☆
MEDIUM: ★ ★ ☆
ADVANCED: ★ ★ ★

There always seems to be a reason to celebrate — birthdays, holidays, slumber parties, pool parties, and more. What do you need at any great party? You need good friends, fun activities, and most of all great food! Recipes in this book will give you great ideas for almost any kind of party. From slumber parties to garden parties, there is something for everyone to enjoy. But don't limit yourself to the recipes you see here. Use these recipes as a starting point and let your creativity take over. Send out invitations, gather your friends together, and get ready to party!

METRIC CONVERSION GUIDE

United States	Metric
¼ teaspoon	1.2 mL
½ teaspoon	2.5 mL
1 teaspoon	5 mL
1 tablespoon	15 mL
¼ cup	60 mL
⅓ cup	80 mL
½ cup	120 mL
⅔ cup	160 mL
¾ cup	175 mL
1 cup	240 mL
1 quart	1 liter

1 ounce	30 grams
2 ounces	55 grams
4 ounces	110 grams
½ pound	225 grams
1 pound	455 grams

Fahrenheit	Celsius
325°	160°
350°	180°
375°	190°
400°	200°
425°	220°
450°	230°

All good cooks know that a successful recipe takes a little preparation. Use this handy checklist to save time when working in the kitchen.

BEFORE YOU BEGIN

READ YOUR RECIPE

Once you've chosen a recipe, carefully read over it. The recipe will go smoothly if you understand the steps and skills.

CHECK THE PANTRY

Make sure you have all the ingredients on hand. After all, it's hard to bake cookies without sugar!

DRESS FOR SUCCESS

Wear an apron to keep your clothes clean. Roll up long sleeves. Tie long hair back so it doesn't get in your way — or in the food.

GET OUT YOUR TOOLS

Sort through the cupboards and gather all the tools you'll need to prepare the recipe. Can't tell a spatula from a mixing spoon? No problem. Refer to the handy tools glossary in this book.

PREPARE YOUR INGREDIENTS

A little prep time at the start will pay off in the end.

- Rinse any fresh ingredients such as fruit and vegetables.
- Use a peeler to remove the peel from foods like apples and carrots.
- Cut up fresh ingredients as called for in the recipe. Keep an adult nearby when using a knife to cut or chop food.
- Measure all the ingredients and place them in separate bowls or containers so they're ready to use. Remember to use the correct measuring cups for dry and wet ingredients.

PREHEAT THE OVEN

If you're baking treats, it's important to preheat the oven. Cakes, cookies, and breads bake better in an oven that's heated to the correct temperature.

The kitchen may be unfamiliar turf for many young chefs. Here's a list of trusty tips to help you keep safe in the kitchen.

KITCHEN SAFETY

ADULT HELPERS

Ask an adult to help. Whether you're chopping, mixing, or baking, you'll want an adult nearby to lend a hand or answer questions.

FIRST AID

Keep a first aid kit handy in the kitchen, just in case you have an accident. A basic first aid kit contains bandages, a cream or spray to treat burns, alcohol wipes, gauze, and a small scissors.

WASH UP

Before starting any recipe, make sure to wash your hands. Wash your hands again after working with messy ingredients like jelly or syrup.

HANDLE HABITS

Turn handles of cooking pots toward the center of the stove. You don't want anyone to bump into a handle that's sticking off the stove.

USING KNIVES

It's always best to get an adult's help when using knives. Choose a knife that's the right size for both your hands and the food. Hold the handle firmly when cutting, and keep your fingers away from the blade.

COVER UP

Always wear oven mitts or use hot pads to take hot trays and pans out of the oven.

KEEP IT CLEAN

Spills and drips are bound to happen. Wipe up messes with a paper towel or kitchen towel to keep your workspace clean.

What? Eat raw fish? Before you say "yuck" to sushi, try this fun snack. It's the perfect food for a party with a Japanese theme. And all you need are ingredients for plain old PB & J.

DIFFICULTY LEVEL: ★ ☆ ☆
SERVING SIZE: 6

PEANUT BUTTER AND JELLY SUSHI

WHAT YOU NEED

●● Ingredients

1 loaf of your favorite bread
peanut butter
jelly (flavor of your choice)

●● Tools

sharp knife

rolling pin

butter knife

cutting board

1 Use a knife to trim the crusts from a slice of bread. Cut the bread lengthwise into three strips

2 Use the rolling pin to flatten each strip of bread.

3 With a butter knife, spread a layer of peanut butter over the flattened bread.

4 Spread jelly over the peanut butter layer.

5 Starting at one end, roll up the bread.

6 Repeat with remaining bread slices.

7 On a cutting board, use the sharp knife to slice the rolls into 1-inch pieces. Your sushi is ready to serve.

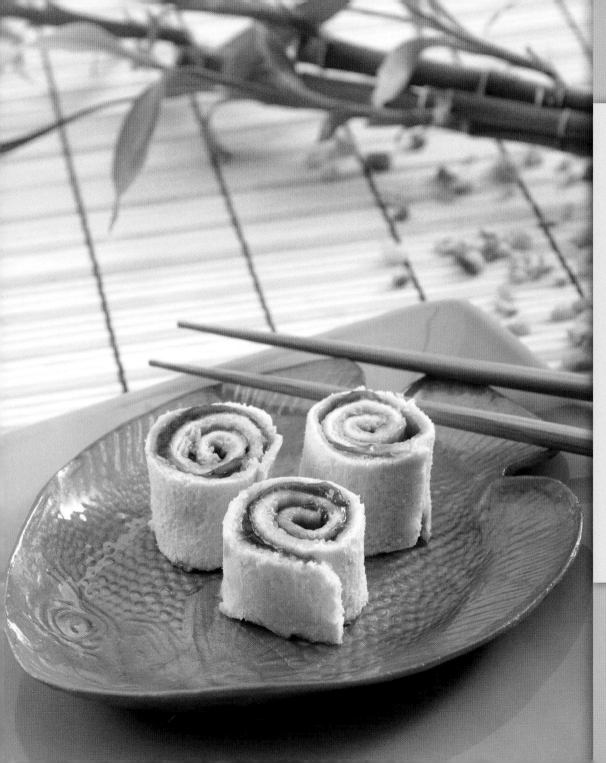

What Is Sushi?

Sushi comes from Japan. A traditional sushi roll has a sheet of seaweed, rice, slices of pickled carrots, cucumbers, or avocados. The vegetables are topped with strips of salmon, raw tuna, or other raw fish. All the ingredients are rolled into a tight log and sliced into 1-inch sections. Sushi is small enough to be eaten in one or two bites. Sushi is usually eaten with chopsticks. Try eating Peanut Butter and Jelly Sushi snacks with chopsticks too.

Summer is the perfect season for pool parties. Serve your guests these refreshing Summertime Fun Icy Pops. They're easy to make and they won't weigh you down in the pool.

SUMMERTIME FUN ICY POPS

WHAT YOU NEED

●● Ingredients

water
powdered drink mixes
(choose your favorite flavors)

●● Tools

pitcher ice cube tray

small wooden
craft sticks

plastic wrap
zip-top plastic bags

1 In a pitcher, make the powdered drink mix, using only half of the recommended water.

2 Pour the flavored liquid into ice cube trays.

3 Cover the top of the ice cube tray with plastic wrap. Poke a small craft stick through the plastic wrap and into each cube.

4 Put ice cube trays in the freezer. Cubes will take about two hours to freeze.

5 When the cubes are frozen, pop them out of the tray and serve.

6 Store leftover pops in a zip-top plastic bag in a freezer.

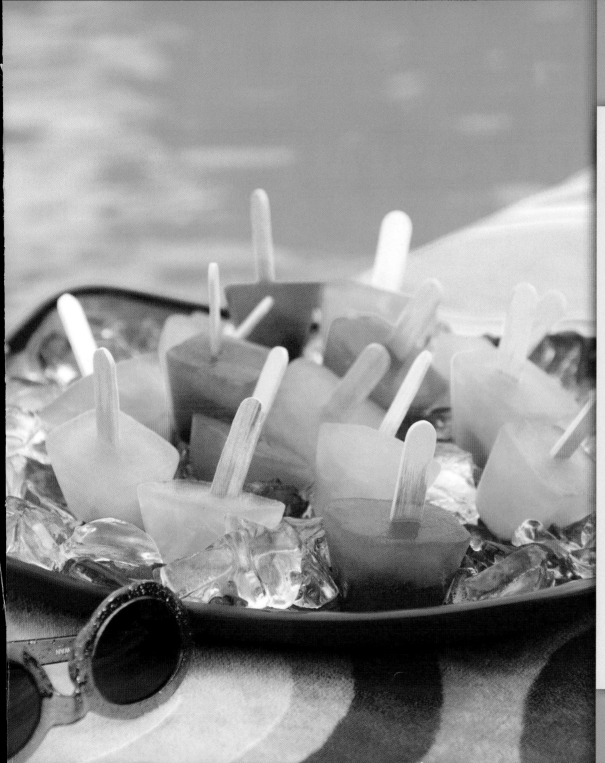

Color Wave

Give your Summertime Fun Icy Pops a splash of color and even more flavor. Combine two drink mix flavors into your ice cube trays. In separate pitchers, prepare two flavors of drink mixes. Fill ice cube trays half full with one flavor. Cover the tray with plastic wrap and add sticks. When the first layer is frozen, fill the tray with the second flavor and freeze.

Trusty Tip

Make Summertime Fun Icy Pops the day before your party. That way, you won't be stuck in the kitchen while your guests are having fun.

11

Slumber parties are for anything but sleep. In the morning, your guests will be a little groggy. Wake up their appetites with these delicious and easy cereal bars.

DIFFICULTY LEVEL: ★ ★ ☆
SERVING SIZE: 6

SLUMBER PARTY CEREAL BARS

WHAT YOU NEED

•• Ingredients

6 cups of your favorite cereal
1/2 cup dried cranberries
1 bag of small mini marshmallows
3 tablespoons butter or margarine

•• Tools

dry-ingredient
measuring cups

mixing bowl

saucepan

rubber scraper

9 x 13-inch
baking dish

wooden spoon

nonstick cooking spray

1 Using dry-ingredient measuring cups, measure cereal and cranberries. Place ingredients into a mixing bowl and set aside.

2 Add marshmallows and butter to the saucepan.

3 Heat marshmallows and butter over medium heat. Stir with a rubber scraper until melted.

4 Pour the melted marshmallows into the mixing bowl. With a rubber scraper, stir until the cereal is completely coated.

5 Lightly coat the baking dish with the nonstick cooking spray.

6 Spread the cereal mixture into the baking dish. With a wooden spoon, press down firmly on the cereal mixture so that it evenly covers the dish.

7 When cool, cut the cereal into bars and serve.

12

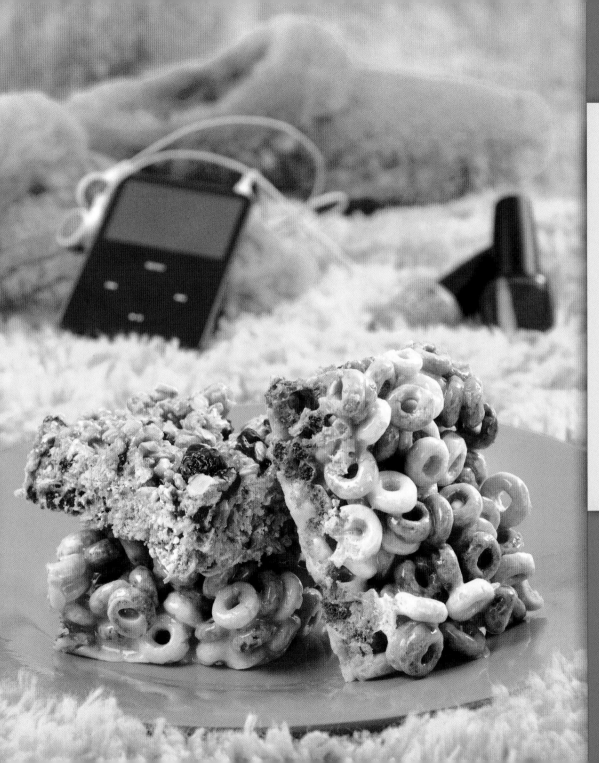

Mixed Up Cereal Bars

Can't decide on which cereal to use? No problem. Just mix several types of cereal to create your own combination. This is a great way to use up that last bit of cereal in the cupboard. Be creative with the name you give your combination. Try making a batch of Fruity Clusters, Cheerio Charms, or Pebble Puffs.

Your friends are coming to watch the hottest new movie. But popcorn is too plain for your guests. Try this sweet and salty snack mix. It's sure to win rave reviews!

DIFFICULTY LEVEL: ★ ★ ☆
SERVING SIZE: 6

MOVIE PARTY SNACK MIX

WHAT YOU NEED

●● Ingredients

1 bag of microwave popcorn
⅓ cup creamy peanut butter
1 cup semi sweet chocolate chips
3 cups Chex cereal
1 cup powdered sugar
1 (8-ounce) can of salted peanuts
1 bag pretzel sticks
1 cup candy-coated chocolate pieces

●● Tools

microwave-safe
mixing bowl

rubber scraper

large mixing bowl

large zip-top plastic bag

1 Prepare microwave popcorn as directed on the package.

2 In a microwave safe bowl, melt peanut butter and chocolate chips for 30 seconds in the microwave. Stir with a rubber scraper. Microwave again for 30 seconds and stir again. Continue this process until chocolate and peanut butter are combined.

3 Add the cereal to the chocolate and peanut butter mixture. Stir with a rubber scraper until cereal is coated.

4 Add powdered sugar and cereal mixture to a large zip-top plastic bag. Seal the bag and shake until the cereal is coated with the powdered sugar.

5 In the large mixing bowl, combine cereal, popcorn, peanuts, pretzel sticks, and candy. Mix the ingredients together with a rubber scraper.

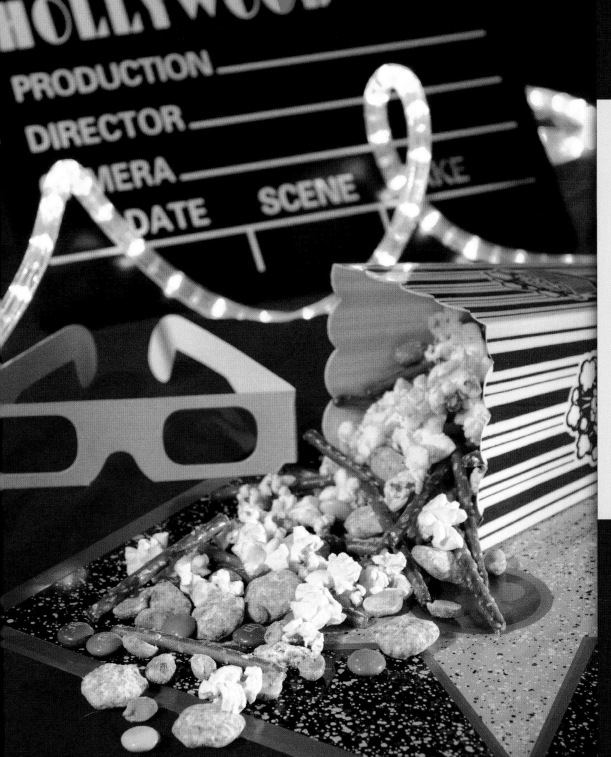

Add to the Mix

Want your snack mix to pop with flavor? Then just toss in more of your favorite snacks. Add sweetness to the mix with licorice or chocolate chips. For a salty twist, add sunflower seeds or soy nuts. Before the party, ask your guests what snacks are their favorites. That way, you can create a snack with ingredients that everyone will enjoy.

15

Ever been bugged by bugs at an outdoor party? Not by these Hot Dog Bugs! They are a sure-to-please appetizer for a summer barbeque or other outdoor party.

HOT DOG BUGS

WHAT YOU NEED

●● Ingredients

1 can refrigerated croissant dough
1 (16-ounce) package of
 cocktail wieners
1 (6-ounce) bag chow mein noodles
ketchup
mustard

●● Tools

small knife

baking sheet

spatula

oven mitt

pot holder

toothpicks

1 Preheat oven to 350 degrees Fahrenheit.

2 Open the can of refrigerated croissant dough. Gently roll out the dough.

3 With a small knife, cut 2-inch strips of dough. Wrap dough strips around cocktail wieners and place them on baking sheet.

4 Bake the wrapped wieners for about 10-12 minutes or until the dough is golden brown.

5 With oven mitts or pot holders, remove the baking sheet from the oven. When cool, remove bugs with a spatula.

6 To form bugs, poke three chow mein noodles into each side of the hot dog body.

7 Dip a toothpick in ketchup or mustard and use it to make the eyes and a mouth. You can even make spots or stripes on their backs.

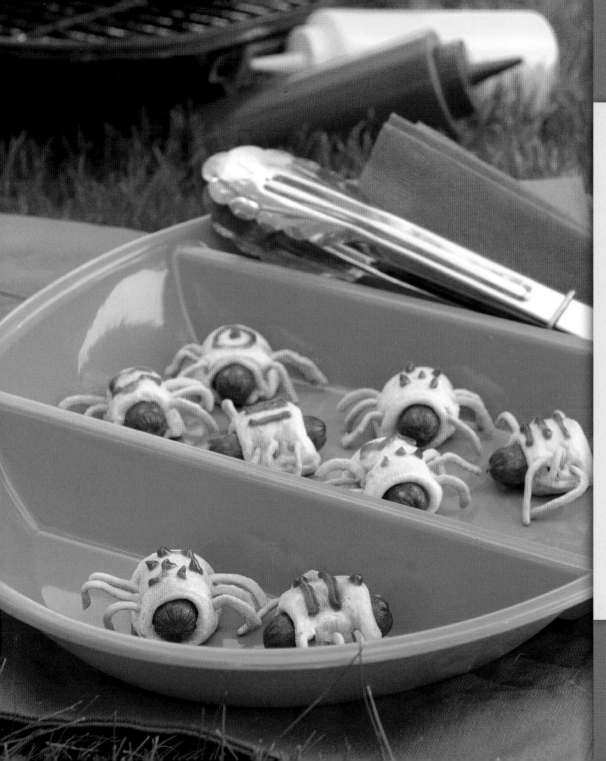

Salty Twist

If you don't have chow mein noodles, don't bug out. You can still make plenty of bugs for your guests. Just use thin stick pretzels for legs instead of chow mein noodles.

Not So Buggy

Not into creepy-crawly things? Use your imagination to create other animals using these basic ingredients. Try making a cat or dog with four legs and a tail made from chow mein noodles. Use the ketchup and mustard to add eyes, a nose, and whiskers.

What's a birthday party without cake? Boring, that's what. Crazy Face Cupcakes are both a treat and party game. Grab your decorations and get ready to be creative!

DIFFICULTY LEVEL: ★ ★ ☆
SERVING SIZE: 12

CRAZY FACE CUPCAKES

WHAT YOU NEED

● Ingredients

1 box of cake mix
 (choose your favorite flavor)
1 bag soft caramels
1 can vanilla frosting
1 can chocolate frosting
Toppings: candy sprinkles, chocolate
 chips, licorice, candy-coated
 chocolates, fruit snacks, nuts

● Tools

electric mixer

mixing bowl

rubber scraper

muffin pan

baking cups

Each guest gets a plain cupcake. Cover it with icing. Then give it a face lift with different toppings. The guest with the craziest cupcake wins a prize.

1 Before the party, make the cake batter according to package directions. You'll need an electric mixer, mixing bowl, and rubber scraper.

2 Line a muffin pan with paper baking cups. Fill each cupcake liner about two-thirds full of batter.

3 Push one soft caramel into each liner of cupcake batter. The caramel should be completely covered.

4 Bake cupcakes according to package directions. When done, allow cupcakes to cool.

5 Set out the decorating ingredients. Have your guests make a creative face on their cupcakes.

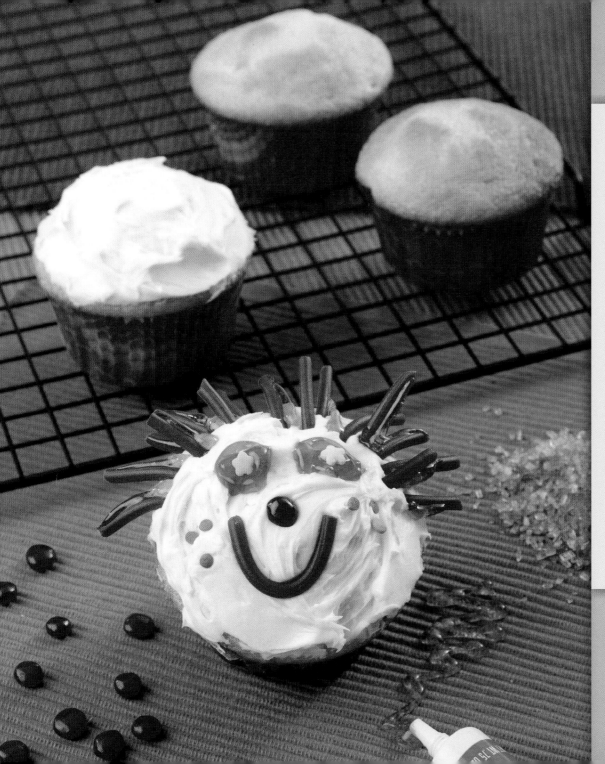

Fancy Faces

Help your guests find their inner artists with these fun and creative decorating ideas:

Have your guests make a face that looks like you.

Invite guests to make cupcake faces that look like their favorite movie star or musician. Ask other guests to guess who the cupcake looks like.

Go crazy with decorations to create cupcakes with scary faces.

After a long night of slumber party fun, your guests are sure to wake up with big appetites. Brown Sugar Bacon Rolls will hit the spot with your hungry guests.

BROWN SUGAR BACON ROLLS

WHAT YOU NEED

Ingredients

1 pound thinly sliced bacon
1 package cocktail wieners
1 cup brown sugar

Tools

baking pan

cutting board

paring knife

measuring spoons

spatula

aluminum foil

1 Preheat oven to 350 degrees Fahrenheit.

2 Line baking pan with aluminum foil. (This step makes for a much easier clean-up.)

3 On a cutting board, slice the uncooked bacon pieces in half with a paring knife.

4 Roll uncooked bacon around cocktail wieners and set them on the baking sheet.

5 Use measuring spoons to sprinkle each bacon roll with a ½ teaspoon of brown sugar.

6 Bake until brown sugar is melted and bacon is done (about 8-12 minutes).

7 Use a spatula to carefully remove each piece from the baking sheet.

8 Serve the bacon rolls on top of some scrambled eggs.

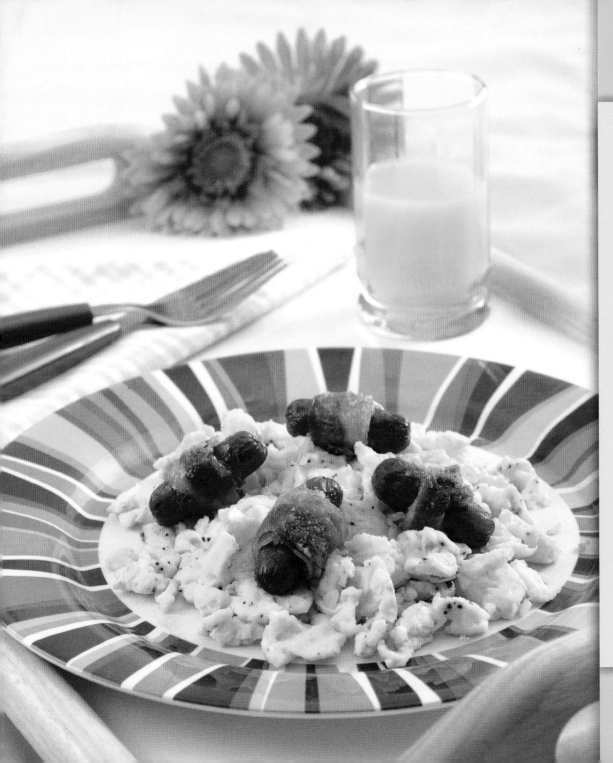

Get Cracking

Scrambled eggs are a tasty breakfast food with or without bacon rolls. To make this dish, crack 12 eggs into a mixing bowl. Add ¼ cup milk, 1 teaspoon salt, and 1 teaspoon pepper to the eggs. Mix the eggs with a fork until the ingredients are combined and the mixture has a yellow color.

To cook, spray a frying pan with nonstick spray. Pour eggs into pan and cook at medium heat. Carefully scrape up puffs of cooked eggs in the pan with a spatula. The eggs are done when they have a light yellow color.

21

Here's a great idea for a garden party. This rich, chocolaty dessert is as delicious as it is fun. You'll be the talk of the neighborhood with treats like this in your garden.

DIFFICULTY LEVEL: ★ ★ ☆
SERVING SIZE: 6

MUDDY GARDENS

WHAT YOU NEED

●● *Ingredients*

1 box dark chocolate
 instant pudding
4 ounces whipped topping
2 cups crushed chocolate
 sandwich cookies
gummy worms

●● *Tools*

mixing bowl

rubber scraper

mixing spoon

small plastic cups

1 In a mixing bowl, prepare instant pudding according to package directions.

2 With a rubber scraper, stir in the whipped topping.

3 Add 1 cup of the crushed chocolate cookies and ½ cup of the gummy worms to the pudding. Stir with a rubber scraper.

4 Spoon mixture into small plastic cups. Leave about ½ inch of space at the top. Refrigerate for 2-3 hours.

5 Sprinkle 1 tablespoon of crushed cookies on top of the pudding mixture in each cup.

6 Top each cup with a few gummy worms.

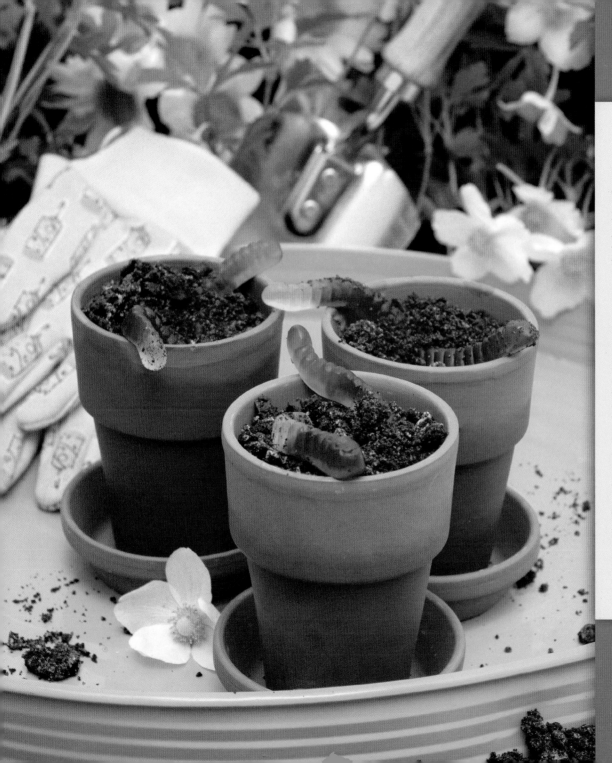

Party Plants

For extra flair, place each of the plastic cups inside a plastic or clay plant pot. Let your guests keep the clay pot as a party favor.

Cookie Crush

Cookie crushing can be messy, but there is a way to keep your work area clean. Put your cookies in a gallon size zip-top plastic bag. Before closing, let the air out of the bag. Then zip it shut. Move the rolling pin back and forth over the bag until all the cookies are crushed.

*Need an excuse to make this groovy treat?
Throw a Back to the '70s Party. These Funky Crunchy
Mallow Balls are far out!*

DIFFICULTY LEVEL: ★ ★ ☆
SERVING SIZE: 12

FUNKY CRUNCHY MALLOW BALLS

WHAT YOU NEED

●● *Ingredients*

1 (3.35-ounce) package
 unbuttered microwave popcorn
1 (10-ounce) bag marshmallows
¼ cup (½ stick) margarine
1 cup Nerds candy

●● *Tools*

large mixing bowl

saucepan

rubber scraper

baking sheet

2 plastic sandwich bags
nonstick cooking spray
baking tray

1 Prepare popcorn according to the package directions. Pour popcorn into a mixing bowl.

2 In a saucepan, melt marshmallows and margarine over medium heat. Stir ingredients with a rubber scraper until combined.

3 Pour marshmallow mixture over popcorn. Use the rubber scraper to fold the ingredients together until the popcorn is completely coated with melted marshmallows.

4 Add Nerds candy to the warm popcorn mixture and stir.

5 Spray one side of each plastic sandwich bag with nonstick spray.

6 Wearing plastic bags as gloves, grab a handful of the popcorn and candy mixture and shape into a ball.

7 Lightly coat a baking sheet with nonstick spray. Place popcorn balls on the baking tray to cool.

24

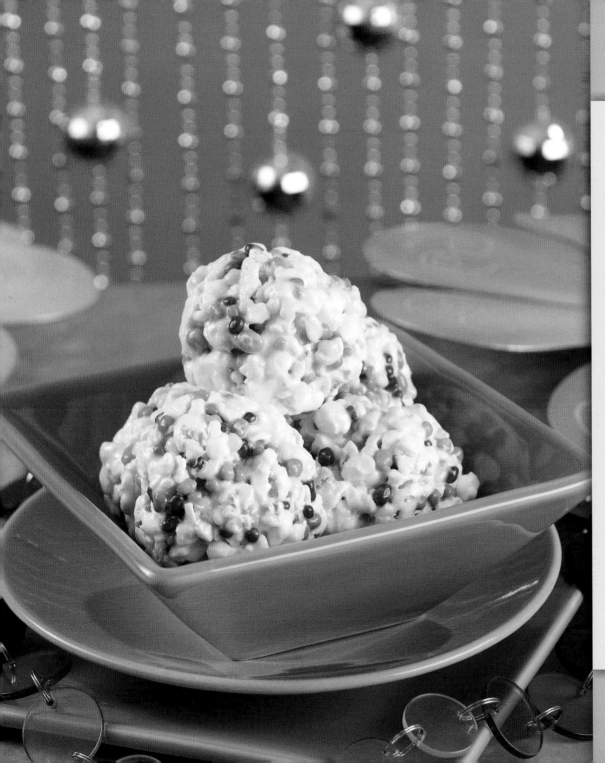

Get colorful!

Give your mallow balls even more color by adding five drops of food coloring to the melted marshmallows. Stir until color is evenly distributed.

You can make lots of different colors from the basic three colors of red, yellow, and blue.

Mix three drops red with two drops yellow to make orange.

Mix two drops red with two drops blue to make purple.

Mix two drops yellow with two drops blue to make green.

Fall means hayrides, harvest parties, and smoothies. Yes, smoothies! This pumpkin smoothie is the perfect treat for a fall party or any time of year!

DIFFICULTY LEVEL: ★ ☆ ☆
SERVING SIZE: 1-2

FALL-TASTIC SMOOTHIE

WHAT YOU NEED

● ● *Ingredients*

1 cup canned pumpkin
1 cup plain yogurt
$\frac{1}{2}$ teaspoon cinnamon
$\frac{1}{2}$ teaspoon nutmeg
$\frac{1}{2}$ teaspoon vanilla
2 teaspoons brown sugar
8 ice cubes

● ● *Tools*

can opener

rubber scraper

blender

1 Open the can of pumpkin with a can opener. With a rubber scraper, empty pumpkin into a blender.

2 Add yogurt, cinnamon, nutmeg, vanilla, and brown sugar to pumpkin.

3 Add ice cubes to the ingredients in the blender.

4 Put the cover on the blender. Using the blender's puree setting, combine ingredients until smooth.

5 Pour equal amounts of smoothie into the glasses and serve.

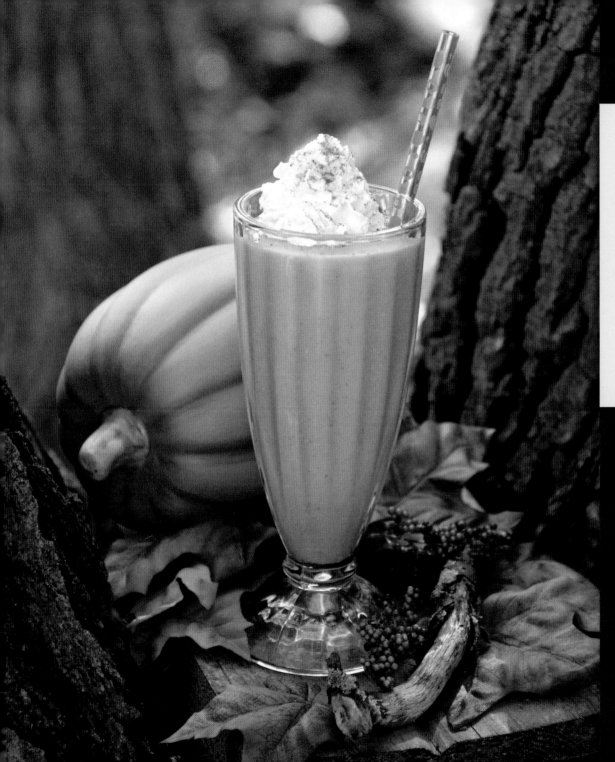

Sweet Start

Give your smoothie some extra sweetness by topping it off with whipped cream. Use prepared whipped topping in a spray can to make a decorative swirl on top of each smoothie. Sprinkle with cinnamon and serve. Yum!

27

TOOLS GLOSSARY

baking pan — rectangular baking pan, usually made of metal, glass, or plastic

baking sheet — a flat metal tray used for baking foods

baking cups — disposable paper or foil cups that are placed into a muffin pan to keep batter from sticking to the pan

blender — small electric appliance with a tall plastic or glass container and metal blades

butter knife — eating utensil often used to spread ingredients

can opener — a handheld tool with a sharp edge used to open canned goods

cutting board — a wooden or plastic board used when slicing or chopping foods

dry-ingredient measuring cups — round, flat cups with handles

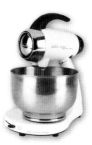

electric mixer — a mixer that uses rotating beaters to combine ingredients

ice cube tray — a tray with small sections that hold water to make ice

measuring spoons — spoons with small deep scoops used to measure both wet and dry ingredients

microwave-safe mixing bowl — a bowl made of plastic or glass that is used to heat ingredients in a microwave

mixing bowl — a sturdy bowl used for mixing ingredients

mixing spoon — large spoon with wide circular end used to mix ingredients

muffin pan — a pan with individual cups for baking cupcakes or muffins

oven mitt — large mitten made from heavy fabric used to protect hands when removing hot pans from the oven

paring knife — a small, sharp knife used for peeling or slicing

pitcher — a container with an open top and a handle that is used to hold liquids

pot holder — thick, heavy fabric cut into a square or circle that is used to remove hot pans from an oven

rolling pin — a cylinder-shaped tool used to flatten dough

rubber scraper — a kitchen tool with a rubber paddle on the end

saucepan — a deep pot with a handle used for stove-top cooking

sharp knife — kitchen knife with long blade used to cut ingredients

spatula — a kitchen tool with a broad, flat metal or plastic blade at the end, used for removing foods from the pans

wooden craft sticks — small flat sticks with rounded ends

wooden spoon — a tool made of wood with a handle on one end and bowl shaped surface on the other

GLOSSARY

appetizer (AP-uh-tye-zuhr) — a small portion of food served before or as the first course of a meal

coat (KOHT) — to cover with a thin layer of something

croissant (krwuh-SAHNT) — a crescent-shaped French bread roll made from buttered layers of yeast dough

fold (FOHLD) — to mix or add ingredients by gently turning the light ingredient over the heavy ingredient

puree (pyoo-RAY) — the process of mixing two or more ingredients into a smooth sauce or paste

sushi (SOO-shee) — a Japanese food made of raw fish or seafood pressed into rice

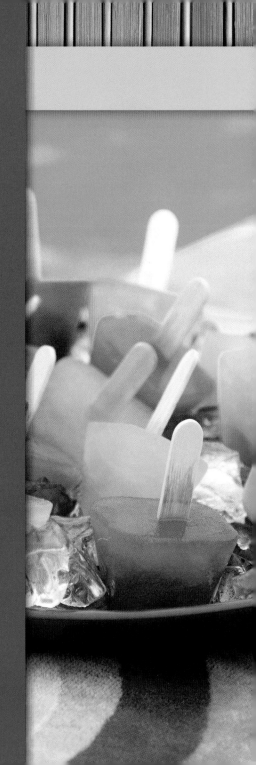

READ MORE

Dalgleish, Sharon. *Party Food.* Healthy Choices. North Mankato, Minn.: Smart Apple Media, 2007.

Ibbs, Katharine. *I Can Cook!* New York: DK, 2007.

Jones, Jen. *Throwing Parties.* 10 Things You Need to Know About. Mankato, Minn.: Capstone Press, 2008.

Wagner, Lisa. *Cool Cuisine for Super Sleepovers.* Cool Cooking. Edina, Minn.: Abdo, 2007.

INTERNET SITES

FactHound offers a safe, fun way to find Internet sites related to this book. All of the sites on FactHound have been researched by our staff.

Here's how:
1. Visit www.facthound.com
2. Choose your grade level.
3. Type in this book ID **1429613408** for age-appropriate sites. You may also browse subjects by clicking on letters, or by clicking on pictures and words.
4. Click on the **Fetch It** button.

FactHound will fetch the best sites for you!

ABOUT THE AUTHOR

Kristi Johnson got her start in the kitchen when she was a little girl helping her mom, aunt, and grandmas with cooking and baking. Over the years, she decided that her true passion was in baking. She spent many days in the kitchen covering every countertop with her favorite chocolate chip cookies. Kristi attended the baking program at the Le Cordon Bleu College of Culinary Arts in Minnesota. After graduating with highest honors, Kristi worked in many restaurants and currently works in the baking industry.

INDEX

Index

Paul III Directing the Continuance of St. Peter's

1544, fresco. Great Hall, Palazzo della Cancelleria, Rome.

The building of St. Peter's dominated the minds of artists

in the sixteenth century, and examples of the basilica

at every stage of construction are rife in Italian art.

Salt Cellar

BENVENUTO CELLINI, c. 1540; ebony base with gold;

10⅛ in. (26 cm). Kunsthistorisches Museum, Vienna.

Cellini used Venus and Neptune to symbolize the land and the
sea on the salt cellar he cast for the King of France. Cellini
fled to the French court after enduring the horrors of the Sack
of Rome in 1527, which he described vividly in his *Autobiography*.

The Courtyard of the Palazzo Vecchio, Florence

A bubbling fountain set within highly decorated columns

graces the interior courtyard of the Palazzo Vecchio in Florence,

a public structure erected between 1298–1340 from the designs of

Arnolfo di Cambio. The building was later restructured by Vasari after

Cosimo I de'Medici came into power and wished to use the palace as a family residence.

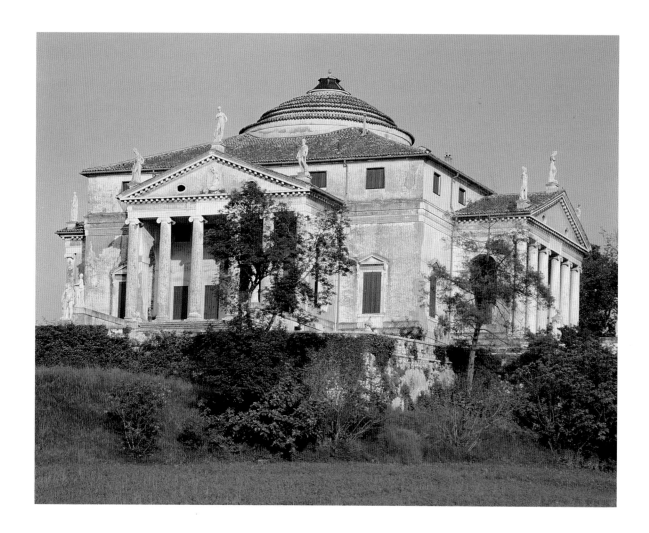

Villa Rotonda (Villa Capra)

ANDREA PALLADIO, 1550; finished by Vincenzo Scamozzi. Vicenza.

The Medici inspired generations of wealthy Italians to build country
villas where their families could retreat from the crowded city during
the summer. These "palaces" were built for entertaining guests,
and provided a pleasure residence for the extended family and friends.

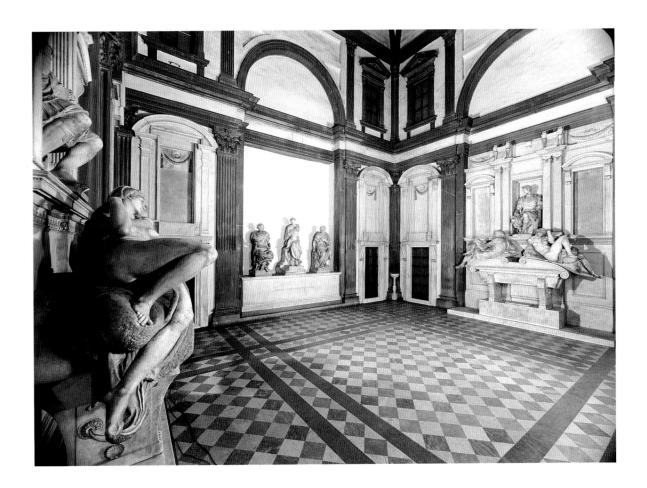

The Medici Chapel

MICHELANGELO, 1519–34. S. Lorenzo, Florence.

After rapidly designing the chapel and tombs, Michelangelo spent the next tumultuous

decade enduring the Sack of Rome (1527) and the re-establishment of the Florentine Republic.

Michelangelo never returned to Florence, and his pupils finally placed the statues on the tombs in 1545.

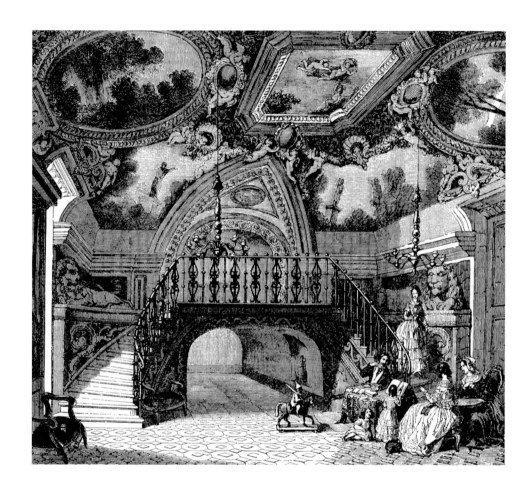

Room in the
Borghese Palace, Rome

An early engraving of the interior of the

magnificent Borghese Palace in Rome offers

a window on aristocratic life in past centuries.

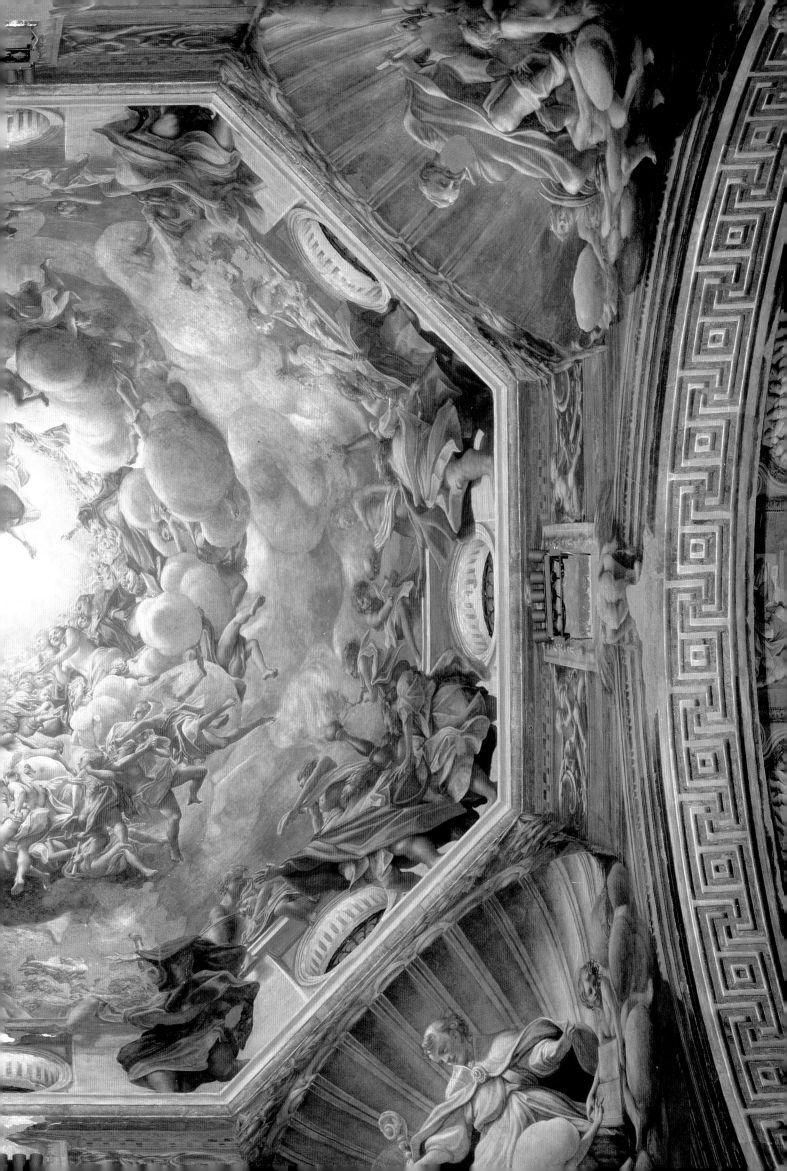

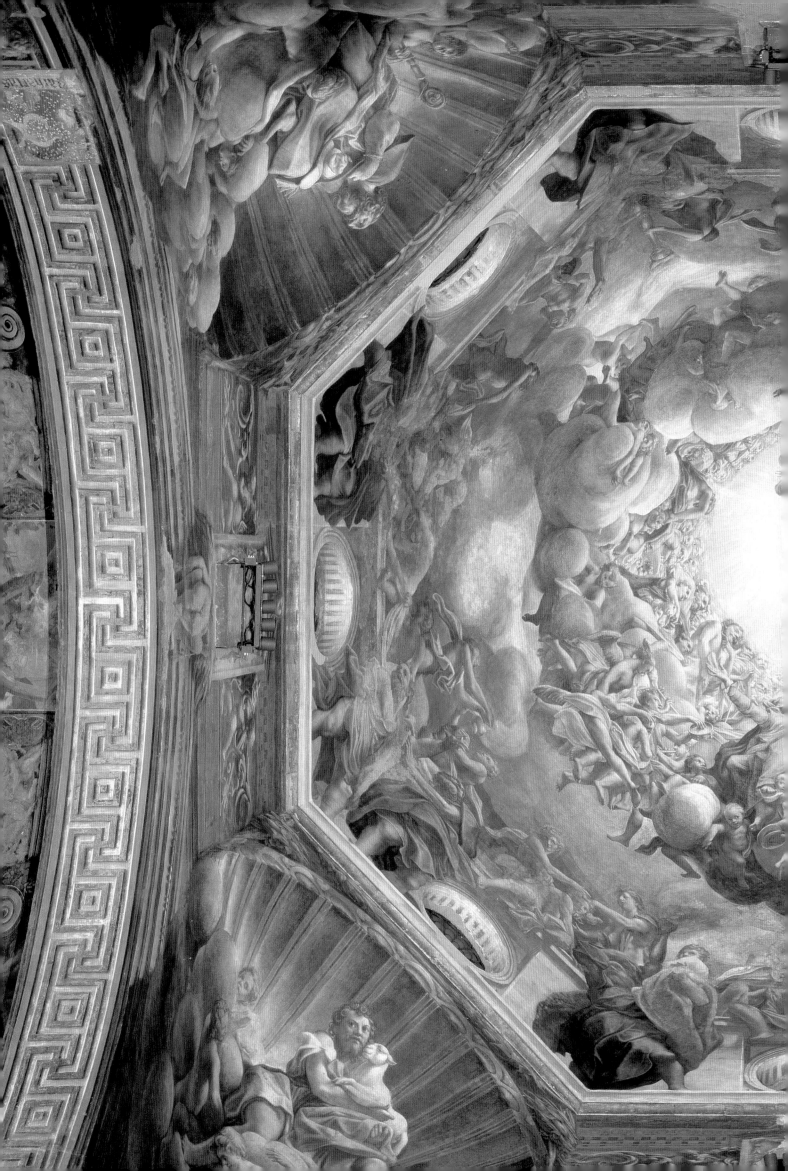

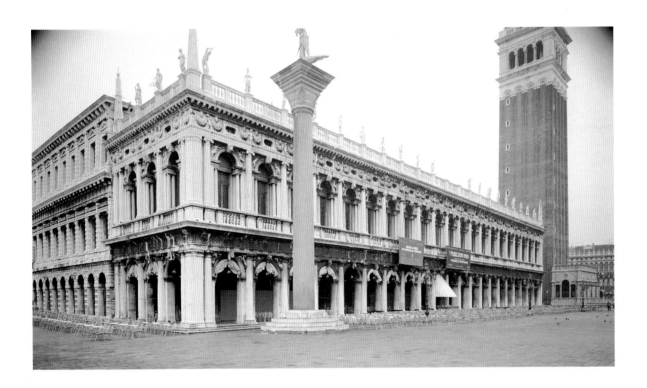

FOLLOWING PAGE:

Vision of St. John the Evangelist

CORREGGIO, 1520–24; fresco. Veduta della Cupola, Duomo, Parma.

With the mastery of realism came the ability to create illusions
transcending the flat barrier of canvas, plaster, and wood.
Looking up into Correggio's dome, the viewer apparently is able
to see through the spiral of clouds and angels into Heaven itself.

119

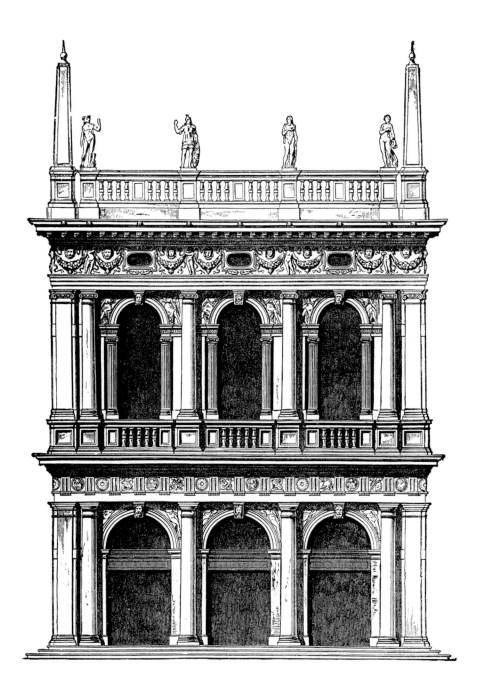

La Zecca (Mint) and Library of S. Marco

JACOPO SANSOVINO, begun 1535. S. Marco, Venice.
Shown here are two views of the Library of S. Marco—one an early engraving, the other a modern photograph. No walls appear on these structures, only clusters of columns and piers. Even the upper contour of the library is broken into verticals by the balustrade, statues, and the obelisks at the corners.

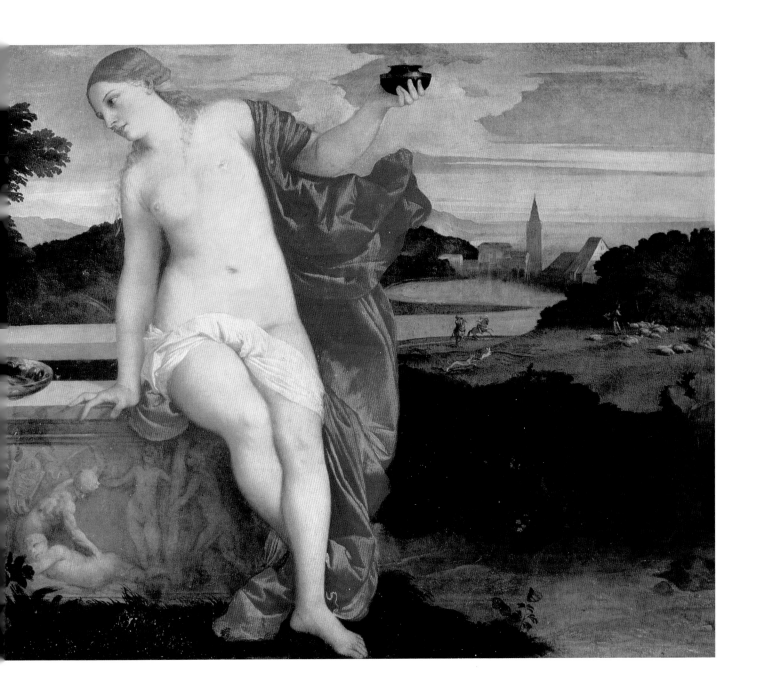

Sacred and Profane Love

TITIAN, 1515; oil on canvas; 3 ft. 11 in. x 9 ft. 2 in. (119.3 x 279.4 cm). Borghese Gallery, Rome.
Some scholars suggest that this was intended to be a Neo-Platonic image
of the Terrestrial and Celestial Venuses. Others claim it is the wedding
portrait of a Venetian nobleman's bride visiting the Fountain of Venus.

The Bacchanal of the Andrians

TITIAN, c. 1522–23;
oil on canvas; 69 x 76 in.
(175.2 x 193 cm).
Prado, Madrid.

Titian modeled the reclining nude in the lower left-hand corner after the *Sleeping Ariadne*, an ancient Roman statue that was imitated often by Renaissance artists.

Cosimo de' Medici, the Elder

JACOPO PONTORMO, c. 1518; oil on wood; 45 x 25¹/₃ in. (87 x 65 cm). Uffizi Gallery, Florence.

As the teacher of Agnolo Bronzino and a contemporary of Rosso Fiorentino, Pontormo was one of the primary creators of the early Mannerist style. Aristocrats loved his sensuous, vibrant portraits which were typical of sixteenth-century Italy.

COSM·MED
ICES·P·P·
P·

faces invariably shine with the glint of satin, porcelain, metal, or polished marble. The attention to the sharp edges of contrast between objects creates a rather stylized effect in his compositions.

Bronzino did endless portraits for the Medici family and the court, and the artist could be accused of the same repetition in facial style that applied to Vasari. In Bronzino's work, however, the idealized masks of his subjects seem to reflect the rigid rule of Cosimo I (duke of Florence and later Tuscany). This restraint can be seen in the artist's *Lucrezia Panciatichi* (c. 1540), which adhered to the traditional usage of clothing to delineate the power and wealth of rulers and courtiers. In most European countries, laws dictated what kinds of materials, colors, and furs could be worn by each rank in order to keep the lower classes from mimicking their betters.

Post-Renaissance Art

The achievements of the High Renaissance remained authoritative for three centuries as artists interpreted, developed, and modified the classical traditions. Baroque painting was a mix of formal applications combined for dramatic appeal, while the naturalists (principally the Spanish and Dutch schools) rejected systems of proportion and relied on painting exactly what the eye could observe. The Renaissance art of allegory exploded: walls, ceilings, entire rooms, and even buildings were decorated with frescoes celebrating the accomplishments and power of various popes, princes, and nobles, albeit cloaked in mysterious and sometimes incomprehensible allusions.

The Bolognese Academy (founded around the turn of the seventeenth century) was the first significant institution to teach an academic philosophy of art based on the Renaissance techniques of studying anatomy and drawing from life. This style renounced the affectations of Mannerism in favor of a vigorous interpretation of nature and an interest in human themes and emotions. The diverse artistic techniques

Lucrezia Panciatichi

Agnolo Bronzino, c. 1540; oil on canvas. Uffizi Gallery, Florence.
Lucrèzia Panciatichi wears red, a favorite color in Renaissance Italy, and she is as conspicuously modern in her jewels as in her dress.

developed during the Renaissance allowed each major sculptor and painter to replicate or manipulate reality at will.

The Renaissance was truly the beginning of the era of modern man, when scholars, philosophers, and artists began the as yet ongoing quest toward understanding reality through systems of observation. Descartes summed up the power of the individual when the philosopher asserted, "I think, therefore I am." As a result of Renaissance explorations, Western civilization moved with energy and expectation into the age of science.

Tintoretto never seemed to hold a grudge against Titian, and he persisted in calling the older artist his master. Tintoretto competed directly with Titian for commissions, and even cut his own bids in order to get work. His rapid style revealed a raw enthusiasm for painting and it gave his work an edge that the more meticulous artists lacked. Tintoretto's colors, though, were never as brilliant as most Mannerist artists because of his tendency to quickly underpaint the basic structure in dark tones of green, brown, or gray.

Tintoretto was able to use this darkness to notable effect in one of his last works, *The Last Supper*, com-

The Last Supper

TINTORETTO, 1592–94; oil on canvas; 12 ft. x 18 ft. 8 in.
(365.7 x 568.9 cm). Chancel, S. Giorgio Maggiore, Venice.
Tintoretto distinguished the spiritual act of communion from the secular environment by placing the table at an angle, separating the Apostles from the servants who are preparing the meal.

pleted in 1594. The highlights that edge the figures—casting an otherworldly ambiance—lends the painting a monumentality despite its realistic, humble setting. Even the angels seem perfectly reasonable as they float in the rays cast by the lamp.

Tintoretto often stages the view from an unexpected angle, but unlike Pontormo he never lets his busy compositions violate the bounds of nature. In this way, his work is similar to Michelangelo's: both artists placed their figures in expressive poses that served the narrative of the subject.

BRONZINO

Bronzino (1503–72) was undoubtedly the best of the late sixteenth century artists. He was the favorite pupil of Pontormo, who painted Bronzino's portrait as a small boy in a cloak seated on the steps, in *Joseph in Egypt*.

Bronzino's style was much more restrained than Pontormo's elaboration of form and figure. His sur-

Sleeping Venus

GIORGIONE, c. 1510; oil on canvas;
42³⁄4 x 69 in. (108.5 x 175.2 cm).
State Art Gallery, Dresden.
This was Giorgione's last
painting, finished by Titian
after his death. The composition
is pure Giorgione, set in the
Venetian landscape with a glint
of the sea in the distance.
The curves of Venus's body
echo the hills that enfold her.

Venus of Urbino

TITIAN, 1538; 47 x 65 in.
(119.3 x 165.1 cm).
Uffizi Gallery, Florence.
Titian copied the pose of
Giorgione's *Venus* but not his
mythological interpretation.
Instead, Titian presented the
goddess as the Renaissance
allegory for romantic love.

earliest of a long series of his reclining female nudes.
A comparison with Giorgione's *Sleeping Venus* (1510)
reveals the same pose, except that Titian's Venus is
awake and directly confronting the viewer in brash
Mannerist boldness.

However, there is a question as to whether the
woman is in fact a representation of Venus because of
the lack of mythological references. In the back-
ground, a servant rummages through a chest at the
order of a lady's maid. Titian's focus is on the abun-
dancy of rich textiles, and seems to suggest that the
nude woman is a mistress to a prosperous Venetian
rather than the fertility goddess whom Giorgione so
lovingly depicted in natural surroundings.

Tintoretto

If Giorgione would have been appalled by his assis-
tant's interpretation of his Venus, Titian himself was
brought into direct competition with Tintoretto
(1518–94), an artist who was once *his* own student.
The meticulous Titian dismissed Tintoretto's ability
the first time he saw one of the boy's rough and
dynamic sketches, kicking the young painter out of
his atelier.

Titian

The next Venetian artist to take the lead after Giorgione was his young assistant Titian (c. 1488–1576). Titian's work exemplified Mannerist developments in the nude figure; he focused on atmosphere and sensuality rather than correctness of anatomy.

His brushwork was singularly notable. Rather than record every detail, Titian used color and light to suggest the form and mood of the subject. The painter's preference for layer upon layer of glazes was well known, and these glazes lend a certain depth and inner light to his scenes. His *Venus of Urbino* (1538) was the

VENICE

With all the political turmoil in Rome and Florence, the cultural center of the Renaissance shifted to Venice during the mid-sixteenth century. Artists such as Titian, Giorgione, Tintoretto, and Veronese took advantage of the eclectic atmosphere of the great sea-faring empire. Venice ruled not only its watery city but a great deal of mainland Italy as well, all in service to the merchant fleets which brought back exotic goods and innovations.

Venice was active, prosperous, and relatively free, unlike the Florentine republic which was under stern Medici rule and therefore captive to the papacy in Rome. Instead of great court commissions, there emerged in Venice works like those of Giorgione, whose brief career is notable for an abundance of moody landscapes. His best-known work is a small painting called *The Tempest* (1505–10). Nothing is known about the identity of the nude woman and the child she is nursing, or why the soldier is standing guard. Indeed, in the earliest reference to the painting, in 1530, Marcantonio Michiel called the woman a "gypsy" and mistakenly attributed the painting to Zorzi da Castelfranco.

When much later the painting was examined by X-ray, it was discovered that under the soldier, Giorgione had originally painted a nude woman. This indicates that the artist had no guiding narrative in mind when he conceived the landscape. This was a typically Mannerist tendency, subverting the ideals of the High Renaissance which called for nobility of subject as well as form.

The Tempest

GIORGIONE, 1505–10;

oil on canvas; 30¼ x 28¾ in.

(76.8 x 73 cm). Accademia, Venice.

The woman seems to be at the mercy of the wild environment, crouching under lowering sky in the weed-choked ruins. The scene seems so utterly believable that generations of critics have tried to find the literary subject that was Giorgione's inspiration.

In 1522 a Dutchman, Adrian VI, was elected Pope (the last non-Italian pope until Pope John Paul II, 1978). Though he only served for two years, this pious northern pope had a huge impact on Roman society. He evicted the entire papal entourage that had established itself around the previous Medici popes—Julius II and Leo X—and also put a stop to all artistic projects at the Vatican, leaving many works uncompleted. Pope Adrian VI was so unpopular with the Italians that his early death is generally believed to have been caused by poison. Pope Clement VII (formerly Giulio de' Medici) was then elected, in 1523, once more putting the Medici's in control of the Vatican.

Rome continued to be the center of power and money during the sixteenth century, but Adrian VI's abrupt dismantling of the papal artist community was not so easily overcome. Florence, too, was becoming culturally stagnant, with much of the commerce under the iron grip of the Medici.

In addition, the Council of Trent (1545–63) set standards of propriety, which can be seen even in the masterpiece of the day, Michelangelo's *The Last Judgment*, in which the nudes are modestly draped with loincloths.

An artist known as Correggio (his real name was Antonio Allegri) also managed, like Michelangelo, to successfully combine elements of the High Renaissance with that of Mannerism. But where Michelangelo's work displays a tension between the natural and the dramatic extremes in presentation, Correggio's figures are soft and yielding, combining sensual textures and surfaces with perfect form. Yet the Church did not censure the nudity in Correggio's paintings because of the sweet purity of faith that infused every work.

Jupiter and Io

CORREGGIO, early 1530s; oil on canvas; 64½ x 28 in.
(163.8 x 71.1 cm). Kunsthistorisches Museum, Vienna.
Correggio painted Io in religious ecstasy at the embrace of Jupiter (in the guise of a dark cloud). Such an erotic rendering was extraordinarily daring, but Correggio's fearless portrayal of the myth stood unchallenged.

most contemporary artists, Michelangelo resisted working for the popes and longed for a return of the creativity he had experienced during his early career in Florence.

Vasari, on the other hand, was determined to please his ecclesiastical patrons with ever-increasing refinements of established, tasteful forms. Indeed, the term "maniera" was first used derogatorily by Venetian artists to describe Vasari's tendency to paint faces and figures alike. But Vasari was quite prosperous, employing dozens of assistants who were amazingly prolific.

The walls of Rome and Florence were covered by Vasari's trademark frescoes—elaborate compositions of patterned lines and gestures that were enhanced for purely decorative effect. Vasari painted *Perseus and Andromeda* for the Studiolo, a room in the Palazzo Vecchio that served as the scientific study for Francesco I de' Medici. The Florentine ruler experimented with alchemy and studied minerals and geological samples. Over thirty paintings and sculpture were commissioned from the best artists of the day to decorate his study.

Vasari also was considered to be an accomplished architect, and his crowning triumph was the Uffizi in Florence, commissioned by Cosimo I in 1560 and not completed until 1580, six years after Vasari's death. The Uffizi is actually a series of buildings, including a house and the Church of San Piero Scheraggio, which were taken over to house the governmental records and offices for the Dukes of Florence. Vasari constructed a unifying façade for the front of the existing buildings, and the result is a claustrophobic, narrow plaza lined with colonnades. At the far narrow end, a small centralized arch allows a beacon of light to enter.

The Last Judgment

MICHELANGELO, detail; 1536–41; fresco. Sistine Chapel, Vatican, Rome.
Among the Apostles who gather around Christ is the figure of St. Bartholomew, the saint who was flayed alive because of his faith. The empty skin bears the distorted face of Michelangelo, an anguished expression of the artist's endless spiritual and artistic struggles.

Perseus and Andromeda

GIORGIO VASARI, 1570–72; oil on canvas; 45½ x 34 in. (115.5 x 86.3 cm). Studiolo, Palazzo Vecchio, Florence.
According to mythology, coral was created from the blood of a dragon who was about to attack Andromeda. When Perseus plunged his sword into the dragon, both its body and blood were turned to stone.

The Counter-Reformation

During the sixteenth century, the Church was concerned primarily with countering the attacks made by the Reform movement. Bitter battles in print and endless negotiations were undertaken to try to reconcile the Reformation with the Catholic tradition. As the Church underwent reform, the Counter-Reformation emerged: a movement that emphasized the holy nature of the sacraments that had been rejected by the Protestants. New monastic orders were formed, such as the Jesuits, whose intention was to defend the faith by word of mouth. There was an increased demand for elaborate altars, relic-shrines, and pictures of the saints and their miraculous deeds.

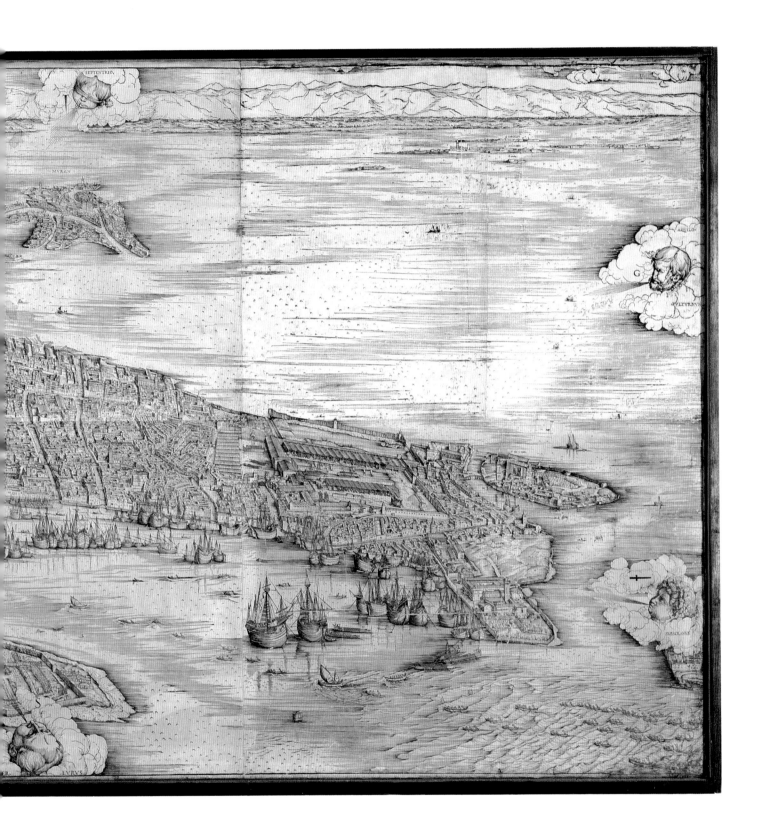

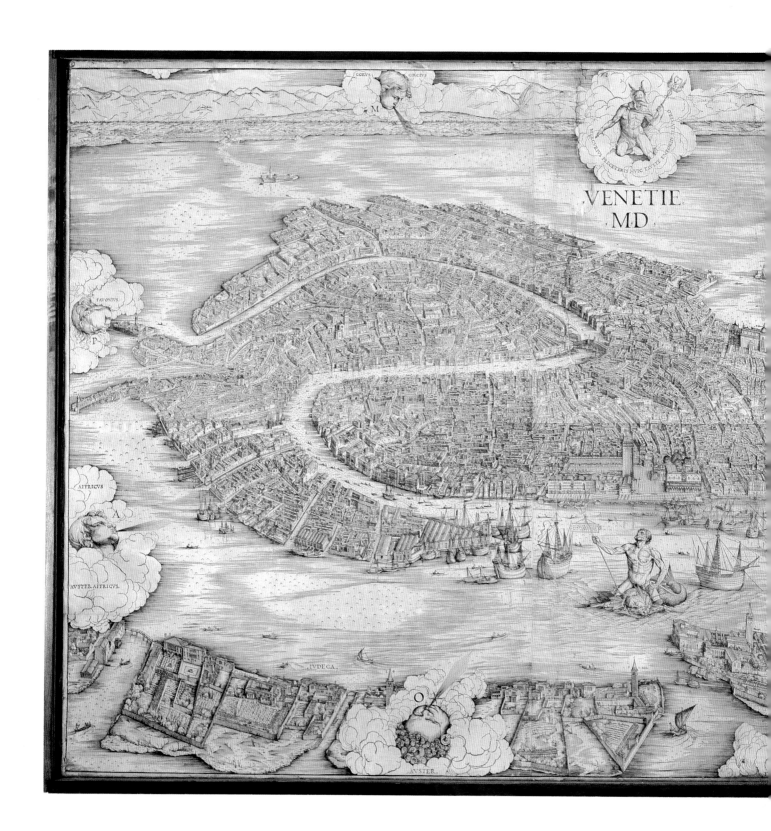

Map of Venice

JACOPO DE BARBARI, c. 1600. Ufficio Direzione Palazzo Ducale, Venice.

The government of Venice consisted of an oligarchy drawn from two hundred of the
most notable families which successfully ruled the only overseas empire of the Italian states.

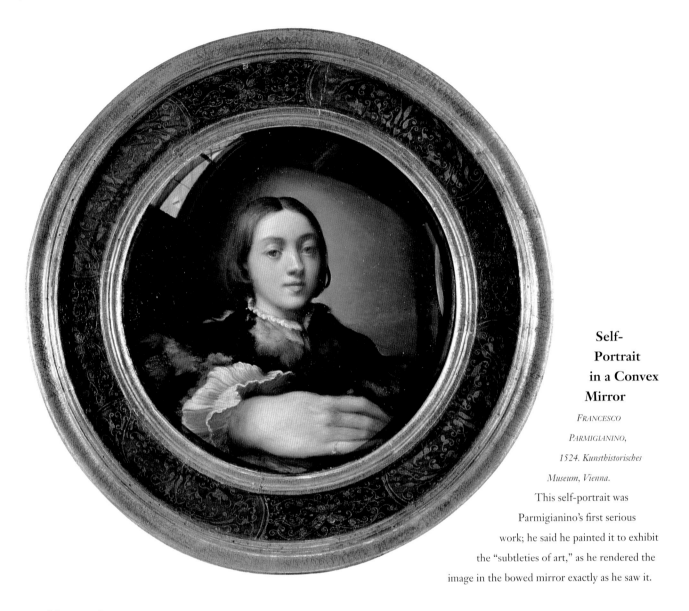

Self-Portrait in a Convex Mirror

FRANCESCO PARMIGIANINO, 1524. Kunsthistorisches Museum, Vienna. This self-portrait was Parmigianino's first serious work; he said he painted it to exhibit the "subtleties of art," as he rendered the image in the bowed mirror exactly as he saw it.

VASARI

The Renaissance was first immortalized in the history of European art by the interpretations of Giorgio Vasari (1511–74) in his *Lives of the Most Excellent Painters, Sculptors and Architects*, published initially in 1550.

Style (*maniera*) was the main concern in Vasari's book, particularly the ways in which art could imitate and surpass nature. According to Vasari, Michelangelo was the supreme artist of all time. Vasari tells how Michelangelo gained his reputation early in his career by carving a Sleeping Cupid that was sold as an ancient work. Though the buyer refused to complete the purchase when he discovered the sculptor was still alive, Michelangelo was praised by other artists for his verisimilitude to ancient forms.

The quality of "grace" that was so prized by the Mannerists was perfected by Vasari and his contemporaries. Artists such as Agnolo Bronzino, Giovanni Bologna, and Benvenuto Cellini believed they were on a par with Michelangelo. They borrowed freely from the art of the High Renaissance—work that was hardly a decade old. The Mannerists copied compositions, figures, and subjects just as eagerly as the artists of the early Renaissance had looked to antiquity for inspiration.

In particular, the Mannerists elaborated on every motif of Michelangelo's work. Michelangelo was reluctantly draped with the mantel of a living legend, and artists flocked to see the master at work on *The Last Judgment* in the Sistine Chapel (1536–41). Unlike

Indeed, many of the conventions of the modern world first emerged during the sixteenth century. The aim of Mannerist art was to emphasize a key element, pushing the strange aspects of subject or form to a new extreme. The emotional response of the figures is usually either overexcited or exaggerated apathy. In Pontormo's *Joseph in Egypt* (c. 1518) the figures assume every conceivable pose, eliminating any comprehension of narrative. Thus art gained in complexity as artists aspired to create ironic contrasts and odd juxtapositions to evoke response from the viewer.

Rather than the well-proportioned, rhythmical compositions of High Renaissance paintings, a Mannerist scene is often seen from an odd angle or spills beyond the frame. Rather than natural poses and interactions, these artists emphasized the artificiality of their world in much the same way that Dadaist or Pop art of the mid-twentieth century would focus on the absurdity of contemporary society by placing everyday objects in the elevated realm of "fine art."

Parmigianino was a young artist when he mastered the Mannerist style, exploiting the distortions of a curved mirror to depict himself in *Self-Portrait in a Convex Mirror* (1524). His face is centered and remains fairly proportional, but the artist's hand is enlarged, curving up the sides of the painting just as the wall and windows of his studio seem to curve down, sickeningly.

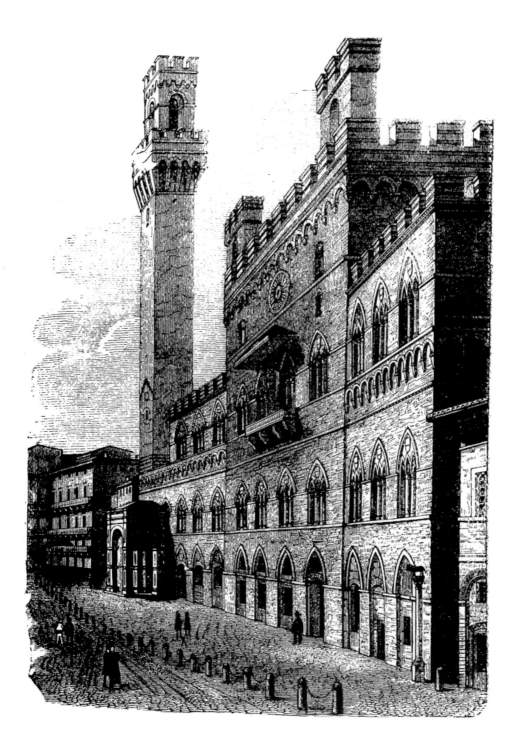

The Uffizi

GIORGIO VASARI, 1560–80. Florence.
Vasari emphasized the narrow length of the plaza with seemingly endless rows of columns and windows. The weight of the façade was so heavy that steel girders were made to reinforce the structures—one of the first uses of metal in construction.

façade so he could create the Medici Chapel in S. Lorenzo which would house the tombs for Lorenzo the Magnificent and Guiliano de' Medici.

While working on the statues for the Medici tomb, Michelangelo also began designing the new library for San Lorenzo, in which to house the enormous Medici collection. For almost thirty-five years, Michelangelo worked on the designs for the Laurentian Library, including an unusually shaped, triangular rare-book room and the desks that were to line the long reading room where scholars would sit to study the manuscripts. In 1557 Michelangelo submitted his last model for the staircase in the Entrance Hall leading up to the library. But he never saw the finished Laurentian Library that was eventually built on top of the monastic buildings connected with San Lorenzo.

Michelangelo's final design for the imposing staircase in the Entrance Hall is a startling blend of sculptural and architectural elements. The curving center steps give motion to the heavy mass that is strikingly counter-echoed by the scroll buttresses. Even the columns are more like statues than architectural supports since they are merely set in the wall, ornamented by decorative scrolls underneath.

The Early Mannerists

The term "Mannerism" was derived from *mano*, the Italian word for "hand." Manual dexterity and technical skill were prized over realism, and artists vied with each other for unique effects.

Critics persisted in considering the Mannerist style a decline from the ideals of the High Renaissance. This derogatory view among art connoisseurs lasted well into the modern age, until the Impressionists' experiments with visual effect led to concerns over pure technique associated with Cubism.

The Entrance Hall of the Laurentian Library

Michelangelo, 1524–34; staircase completed 1559.

Laurentian Library, S. Lorenzo, Florence.

The curving, fluid steps of Michelangelo's staircase have no precedent in classical or Byzantine architecture.

Mannerism

Once the classical models had been thoroughly mastered and embellished, artists began to break the old rules. The correct proportions of the human body could be altered for specific effects—the eyes made larger or the neck longer as in Parmigianino's *Madonna of the Long Neck* (1534–40). The constraints of linear perspective could also be set aside in order to attain a more dramatic result. Mannerism represents aspects of High Renaissance style taken to their limits.

Michelangelo was such a creative genius that many of the Mannerist experiments can be credited to the inspiration of his work. His philosophy of pure creativity naturally prompted him to explore art simply for "art's sake." This was a natural step taken once Renaissance artists began to be acknowledged as individual creators. They stretched customary artistic boundaries based on their own inclinations, defending their actions with the Delphic mandate "know thyself."

Michelangelo had more reason than most artists to wish to be free of the contradictory demands of others. He had yet another disappointment after three years of working on the plans for the façade of the Church of San Lorenzo. He had barely quarried enough marble for the statues that were intended to decorate the niches when his contract was canceled. In 1520, after the death of Lorenzo, Michelangelo was pulled off the

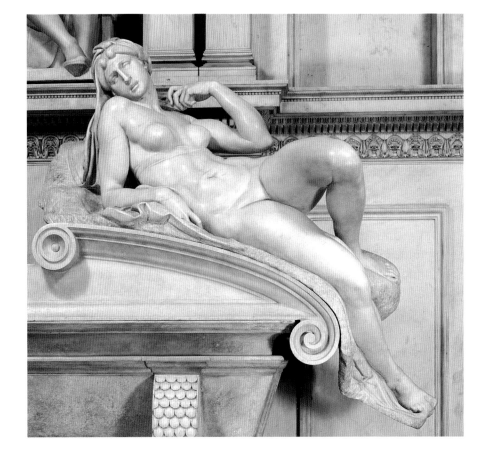

Dawn

Michelangelo, 1524–34; marble.

Tomb of Lorenzo de' Medici, Medici

Chapel, S. Lorenzo, Florence.

Nude figures representing Night and Day, Dawn and Twilight decorate the sarcophagi. These figures were probably intended to symbolize the perpetual celebration of Mass and the prayers that would be said for the salvation of the dukes' souls.

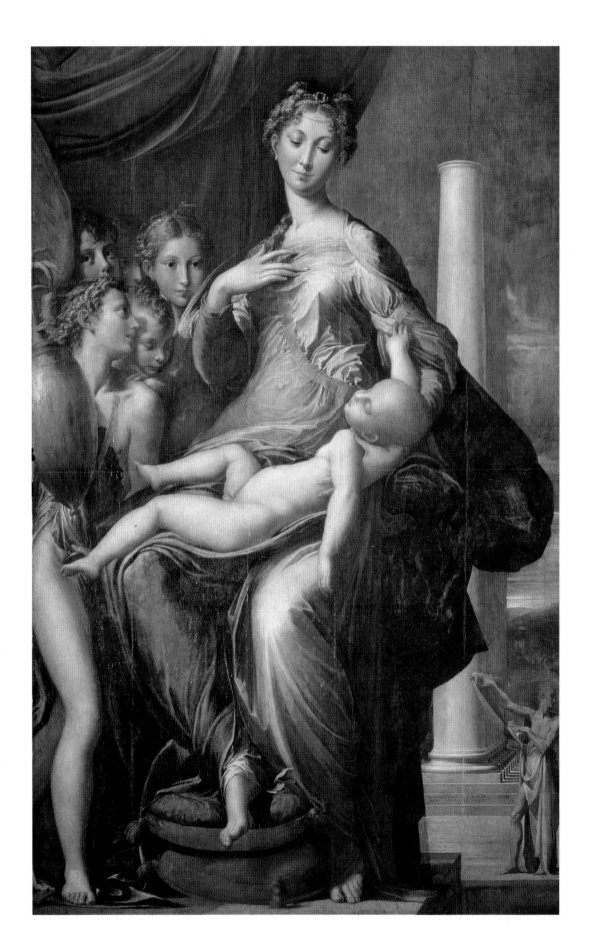

Madonna of
the Long Neck

*Francesco Parmigianino,
1534–40; panel; 85 x 52 in.
(215.9 x 132 cm).
Uffizi Gallery, Florence.*
By manipulating the
proportions and elon-
gating the Madonna's
neck, Parmigianino
has created an impres-
sion of exaggerated
refinement. The unusually
large size of the child
sprawling across Mary's
lap deliberately evokes
parallels with the Pietà.

The Damned Cast into Hell

LUCA SIGNORELLI, 1499–1504; fresco.

S. Brixio Chapel, Cathedral, Orvieto.

In an attempt at the ultimate realism, Signorelli's figures turn and appeal to the viewer for help. The demons are shown in parti-colors, like the uniforms of German soldiers who would eventually be successful in invading Italy and sacking Rome.

Santa Maria della Consolanzione

Unknown architect, 1508. Todi.

The architect of this church is unknown but the design could only have come from someone with a mastery of classical art. This is one of the few centralized churches that was actually built during the Renaissance.

Virgin of the Rocks

LEONARDO DA VINCI, c. 1485; oil on wood; 6 ft. 3 in. x 3 ft. 7 in. (190.5 x 109.5 cm). The Louvre, Paris.

The landscape is fantastical in its dramatic effect, yet Leonardo carefully included authentic

geological details which he had observed in his travels as well as maintaining strict botanical accuracy.

Perseus Liberating Andromeda

PIERO DI COSIMO, c. 1510; panel; 25³/₄ x 72¹/₄ in.
(65.4 x 183.5 cm). Uffizi Gallery, Florence.
Piero di Cosimo's clean, simple style was
best employed in natural settings. His lively
animals are reassuringly familiar and lifelike,
even when he depicts fantastical monsters.

Vision of St. Bernard

FRA BARTOLOMMEO, 1504–07; panel;
7 ft. x 7 ft.¼ in. (213.3 x 213.9 cm).
Uffizi Gallery, Florence.

Raphael's debt to Fra Bartolommeo
can be seen in the monk's idealized
realism, particularly in his image
of a floating Madonna, the first in
a long line of High Renaissance
Madonnas that are symbolically
raised above the other figures.

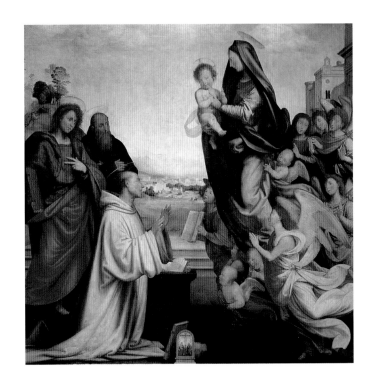

Sistine Madonna

RAPHAEL, 1513; oil on canvas; 8 ft. 8½ in. x 6 ft. 5 in
(265.4 x 195.5 cm). Gemaldegalerie, Dresden.

Raphael painted this Madonna to be hung
over the bier of Pope Julius II upon his death.
The painting is grounded by the two putti at the
bottom, which have been reproduced since on
everything from greeting cards to wall stencils.

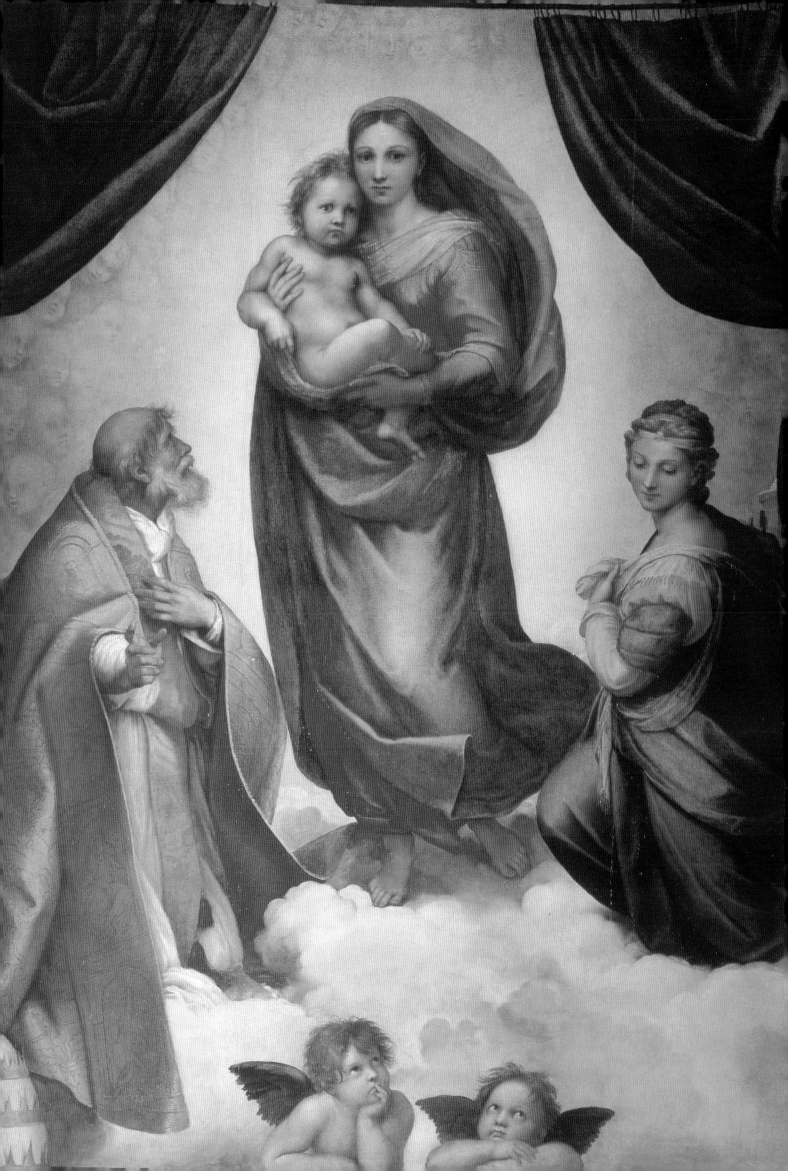

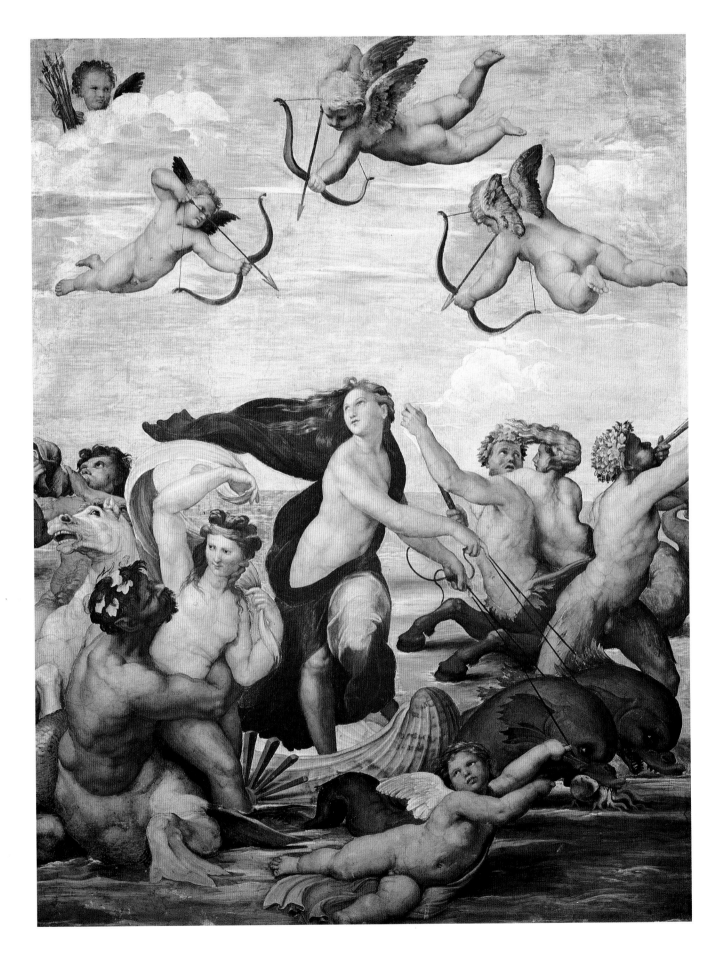

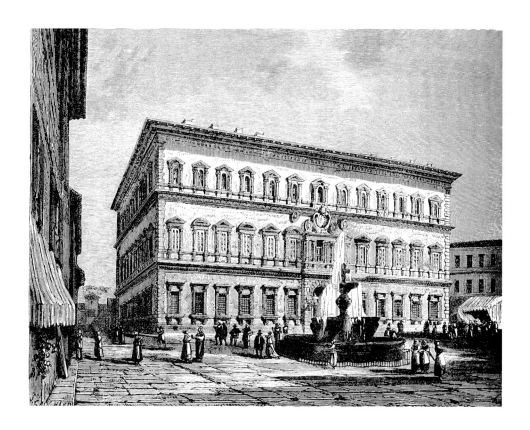

The Farnese Palace

ANTONIO SANGALLO, c. 1530–1546. Rome.

The broad majestic front of the Farnese Palace,
built for Cardinal Farnese, asserts to the public
the royal and papal pomp of this great family.
The original, rather modest palace was enlarged
after the cardinal was elected Pope Paul III in 1534.

Galatea

RAPHAEL, 1513; fresco. Farnese Palace, Rome.

Raphael painted Galatea as his ideal of womanly
perfection, taking the best features from a
number of actual models. She is encircled by
figures while her body twists into a figure eight,
creating a balanced yet dynamic composition.

decorated was the Stanza della Segnatura (completed c. 1511), named after the highest papal tribunal. Raphael set out to paint the ideals of Julius's reign, one on each wall. The *Disputa* was a representation of contemporary theological concerns, while the opposite wall symbolized secular learning in *The School of Athens*.

The two central figures in *The School of Athens* are Plato and Aristotle, surrounded by scores of ancient philosophers and scholars. Raphael gave many of the figures the physical characteristics of the great men in his day: Plato is Leonardo da Vinci; Heraclitus, who is seen writing on a block of stone in the immediate foreground, is Michelangelo; while Euclid, among the figures on the right, is represented by Bramante holding a compass against a slate.

Fittingly, in the sky over the central arch, Raphael painted the unfinished basilica of St. Peter's, as yet uncapped by the great dome that Michelangelo would later design.

Charge to Peter
(Christ Giving the Keys to St. Peter)

PIETRO PERUGINO, 1481; fresco. Sistine Chapel, Vatican, Rome.

As a master of the Early Renaissance, Perugino emphasized the architectural structure of the piazza and polygonal temple over the figures. From Perugino, Raphael learned the importance of visual symmetry.

FOLLOWING PAGE:

The School of Athens

RAPHAEL, 1509–11; fresco. Stanza della Segnatura, Vatican, Rome.

Plato and Aristotle appear in the center: Plato, on the left, holds the *Timaeus* while pointing upward to indicate the spiritual basis of his philosophy. Aristotle holds a copy of his *Ethics* and motions downward with his palm, indicating that his philosophy is based in earthly concerns.

The Marriage of the Virgin

RAPHAEL, 1504; panel; 67 x 46½ in. (170.1 x 118.1 cm). Brera Gallery, Milan.
Even in his early works, Raphael shows his mastery of High
Renaissance ideals. The figures are clustered into three ring-shaped
groups, allowing the eye to move easily from one to the other.

RAPHAEL

Raphael (1483–1520) is not considered to be as innov-
ative as Leonardo da Vinci or Michelangelo, yet his
work is even more quintessentially a product of
the High Renaissance. His idealized figures move
naturally within space, and his classically harmonious
compositions are often based on a series of circular
configurations.

Raphael was trained by Perugino when
he was a teenage boy, and his early paint-
ings are very similar to those of his mas-
ter—one glance at Raphael's *The
Marriage of the Virgin* (1504) and
Perugino's *Charge to Peter* (1481) reveals
the same composition: a foreground
frieze of figures with a polygonal temple
in the background of the vast piazza.

At this early point in his career,
Raphael was still copying the cool colors
of Early Renaissance painters such as
Perugino, Masaccio, Piero della
Francesca, and Mantegna. His mature
work has greater depth and color, with
dark, shimmering distances that suggest
the natural play of light and shadows.
Raphael's figures are seemingly real yet
they are idealized to such a degree that
his paintings tend to have a transcenden-
tal impact.

Unlike Leonardo or Michelangelo,
Raphael did not render his models in
terms of their anatomy or individuality.
He often combines characteristics from
various models, and softens features to
utmost perfection. In multi-group com-
positions, Raphael creates a sense of "rightness" by
balancing the figures against one another. Thus his
paintings can be instantly viewed and appreciated as
a whole, with color, line, and mass enlivening the
carefully arranged gestures and radiant, passive
expressions.

It was this very detachment that made patrons seek
out Raphael as a portraitist. He was not interested in
evoking a mood or capturing reality. His abstraction of
form and line served to sum up brilliantly the essence
of his sitters, while putting them physically in the best
possible light.

When Raphael went to Rome in 1508, Pope Julius
II immediately commissioned him to paint the walls
of his Vatican apartments. The first room Raphael

Leonardo's experiments with oil pigments, however, were destined to be a disappointment. While his Madonna panels retain an astonishing depth and clarity despite the fine crackled surface of the glazes, Leonardo's large wall mural of *The Battle of Anghiari* (1503–06) was a failure. This painting for the Palazzo Vecchio was commissioned to commemorate the Florentine victory in 1440 against the Milanese duke Filippo Maria Visconti. Leonardo began work on the mural but, when the pigments began to sag and slide down the wall, he abandoned it in 1506.

Between 1506 and 1557 (when Vasari repainted the wall as part of his series on Grand Duke Cosimo I) thousands of artists viewed Leonardo's partially completed work. Today, this lively composition exists only in Leonardo's original sketches, and in copies made by other artists. *The Battle of Anghiari* was one of Leonardo's last works of art, and for the remaining ten years of his life the artist rarely even sketched (he spent more time on scientific pursuits) as he enjoyed a luxurious life in France under the patronage of King Francis I.

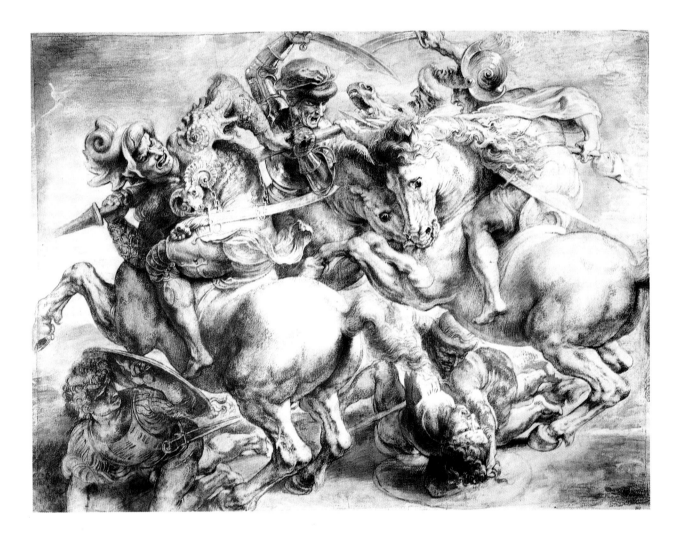

The Battle of Anghiari

LEONARDO DA VINCI, 1503–06; oil on plaster; copy by Peter Paul Rubens; c. 1615; pen and ink and chalk; 17¾ x 25¼ in. (45 x 64.1 cm). The Louvre, Paris.

The action of these figures creates an intensity and internal rhythm through the interlocking heads and hoofs and swords. This conveys the sensation of battle rather than its mere appearance.

Drawings of an Infant

LEONARDO DA VINCI, c. 1510–12. Accademia, Venice.

In his search for scientific accuracy, Leonardo was not satisfied until he had examined and sketched every part of man from every angle, including this page of drawings of a young child.

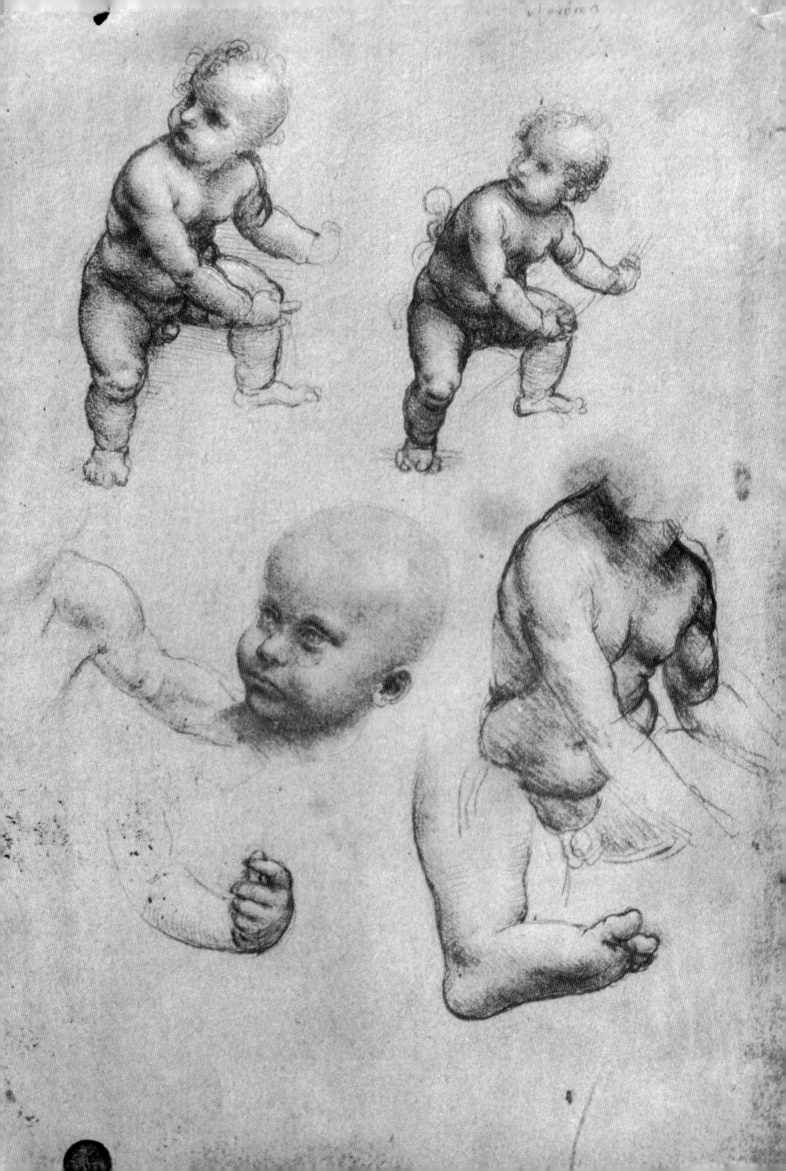

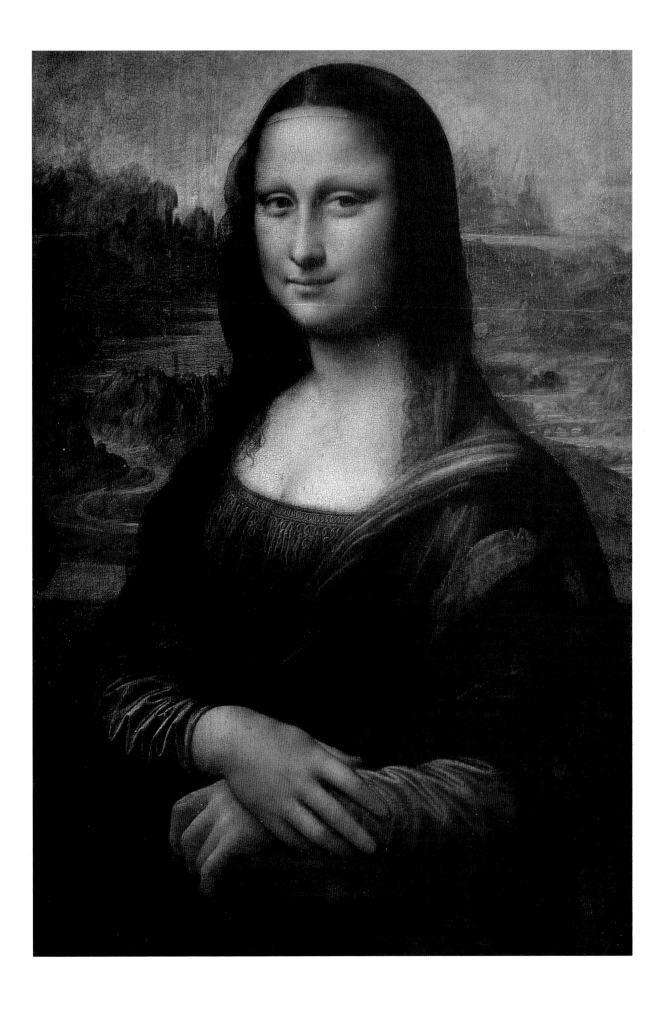

LEOПARDO

Leonardo da Vinci (1452–1519) was an elder states-man among the artists of the High Renaissance. His interests included not only the arts of painting, sculp-ture, and architecture but science and engineering as well. He explored the natural world in all its guises: botany, zoology, anatomy, geography, mineralogy, and the study of the stars.

A great deal is known about Leonardo's motivations and philosophy through his essays and extended notes which were randomly bound together into notebooks. Leonardo sketched out machines that would not be in-vented until centuries later, and his drawings of human anatomy are supreme examples of Renaissance inquiry into biological functions. He dissected plants and drew cross sections through flesh and musculature to cap-ture every detail of physical forms, as if searching for some sort of underlying commonality. Leonardo also visited the public baths (as did Dürer) in order to directly observe the movement of naked bodies.

Though he could be quite charming and conversa-tional, Leonardo was detached even from those who were closest to him. He cared little for the conven-tions of the day, and he completely rejected orga-nized religion and personal spiritual matters. Leonardo was quite the modern man, placing more faith in science and nature than in God. When he lived in Milan, he often climbed the Alps and his in-quiring eye soon noted the abundance of fossilized shells in the rock, leading him to conclude that the world could not have been created in 4004 B.C., as the Church had decreed.

Leonardo was driven by his insatiable curiosity, re-peatedly writing in his notes, "Who will tell me if any-thing was ever finished?" His drawings were so accurate that many of his machines were built in the early twentieth century when modern metal alloys were forged. Leonardo designed pumps, pulleys, lens grinders, and mobile machines (including flying ma-chines) as well as weapons and defense structures.

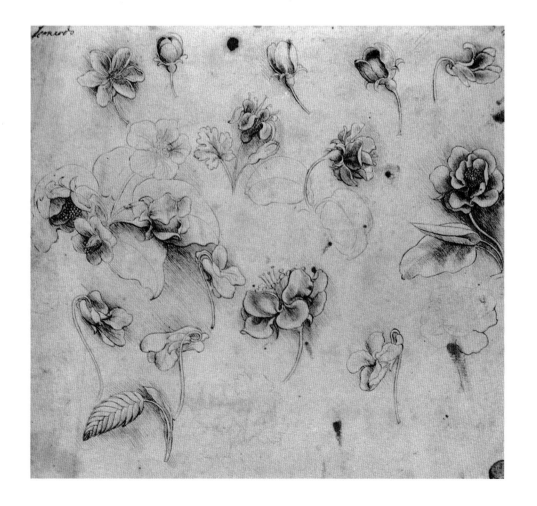

Flower Studies

LEONARDO DA VINCI, c. 1505–08;

pen on paper. Accademia, Venice.

As catalogues of medicinal plants were created in the sixteenth century, a need arose for exacting drawings which could be used as examples. Leo-nardo's keen and informed eye helped show the way for illustrators of botany.

Mona Lisa

LEONARDO DA VINCI, c. 1503–05; oil on wood;

30 x 21 in. (76.2 x 53.3 cm). The Louvre, Paris.

Renaissance women, such as Marguerite of Navarre and Queen Elizabeth of England, occasionally held posts of power. But most were simply wives or mothers, and are best represented by Leonardo's enigmatic *Mona Lisa*, a figure who continues to intrigue modern man with her mysterious smile.

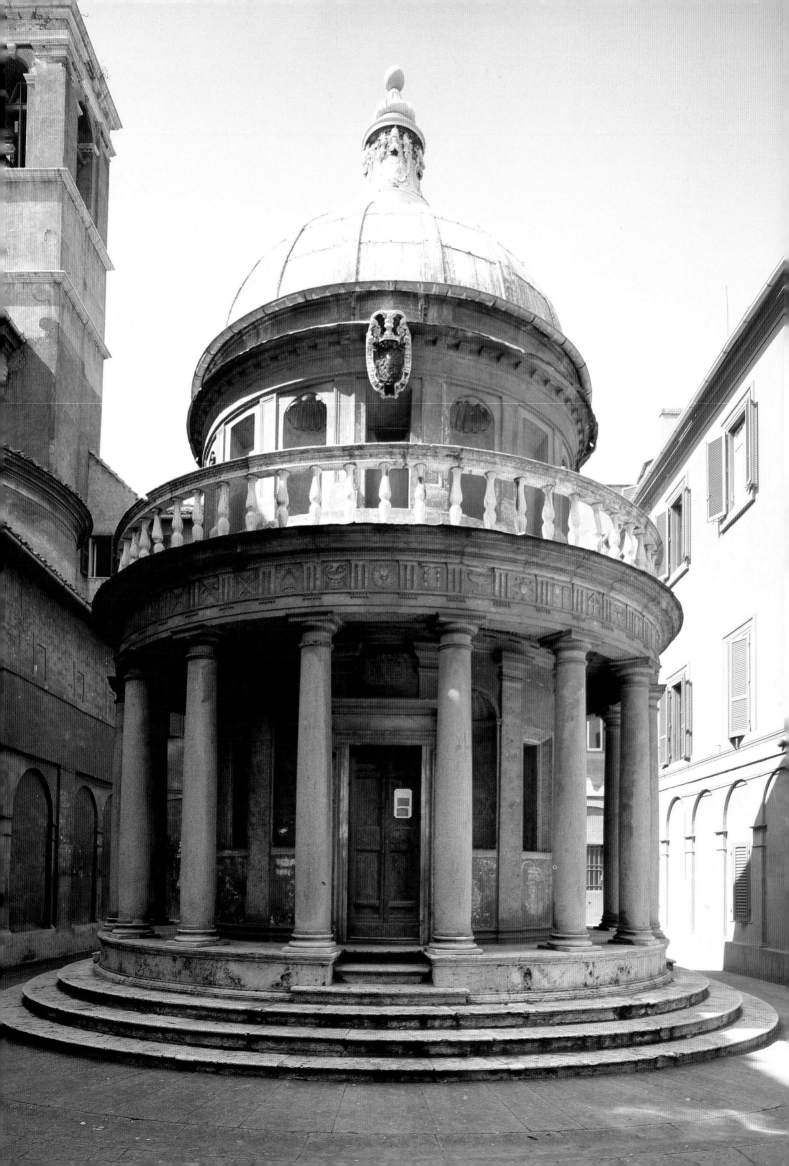

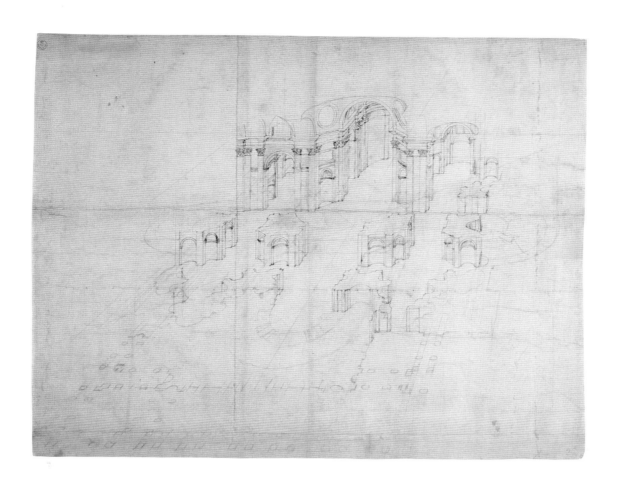

Design of Elevation for St. Peter's

DONATO BRAMANTE, 1506; pen drawing. Gabinetto dei Disegni e Stampe, Florence. Bramante's centralized church plan was classically perfect, but the Greek cross design did not suit the needs of the liturgy because the altar could only be seen from one aisle.

BRAMANTE

Bramante (c. 1444–1514) was a mature artist when he arrived in Rome shortly before the election of Pope Julius II. He was commissioned by Ferdinand and Isabella of Spain to design a shrine to be built on the spot of St. Peter's crucifixion, next to the church of San Pietro in Rome.

The circular *Tempietto* (1502–11) was originally intended to be surrounded by a circular courtyard. Bramante designed the structure so that the outer edge of the courtyard was surrounded by a colonnade of widely-spaced columns, each one echoing a column in the Tempietto. In its present location, squeezed into a narrow courtyard, the Tempietto seems more like a sculpture than a building.

When Julius II decided to reconstruct St. Peter's, he hired Bramante in 1506 to draw the designs. The artist lived to see the construction of the four main arches that would eventually support the enormous dome, and he supervised the laying of the foundations for most of the cross and some of the side chapels. He intended for the apse to have three bays, with the huge tomb of St. Peter at the crossing.

As building continued though the decades, the design of the great cathedral was transformed and altered by a succession of inspired architects. The job was eventually completed by Michelangelo, who adapted Bramante's original plans for the exterior and the dome.

Tempietto

DONATO BRAMANTE, 1502–11. San Pietro in Montorio, Rome. Bramante based the design for this tiny structure on the symmetrical plan of the Roman Temple of Vesta. It is one of the key structures in architectural history because of the influence of its centralized design.

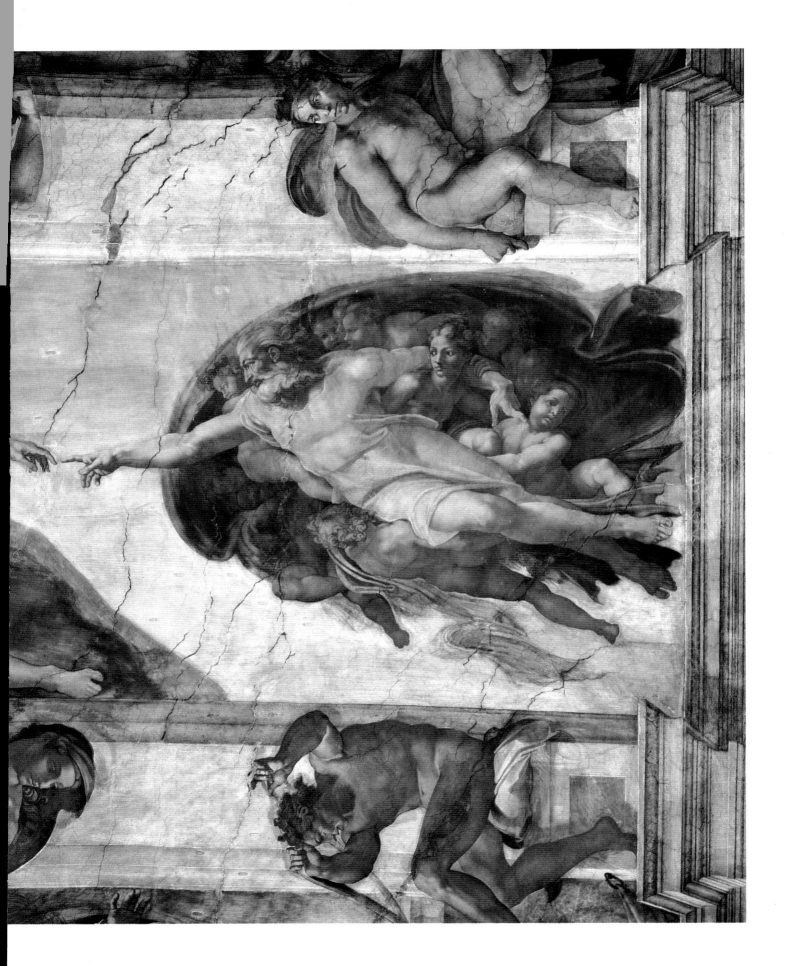

ateliers were full of apprentice artists who were expected to perform much of the basic work of their master's commissions.

Michelangelo rejected the new techniques made available by oil pigments, preferring the traditional fresco method of applying pigment directly to wet plaster, forming an unbreakable bond between the two. This is why Michelangelo's frescos are nearly as fresh and alive today as they were the day he painted them, easily cleaned by water and light abrasion. Unfortunately many of Leonardo's paintings, in which he experimented with fragile oils and tinted glazes, have disintegrated under centuries of exposure and restoration.

The nine scenes of the Sistine Ceiling alternate between large and smaller rectangular sections that are supported by pagan sibyls and Hebrew prophets. The ancestors of Christ, as per the Gospel of St. Matthew, are painted in the triangular spandrels and semicircular lunettes above the windows. The architectural plinths between the large sections are an illusion Michelangelo painted on the curving vault.

In order to convey the biblical narratives, Michelangelo used his skill to idealize the essence of each scene into a few key figures and gestures. Like Leonardo, Michelangelo was obsessed with perfect anatomy: for Leonardo it was a statement of a scientific absolute, while Michelangelo believed that an image of perfect beauty could somehow transcend mere physicality by revealing the soul.

Michelangelo finished the entire ceiling just before Julius II's death early in 1513. The Tomb project was once again revived and reduced, as Michelangelo rapidly completed three major works which were to decorate the monument: the sculpture of Moses and two slaves who writhe in bondage—perhaps in memory of his own bondage to the tyrant patron.

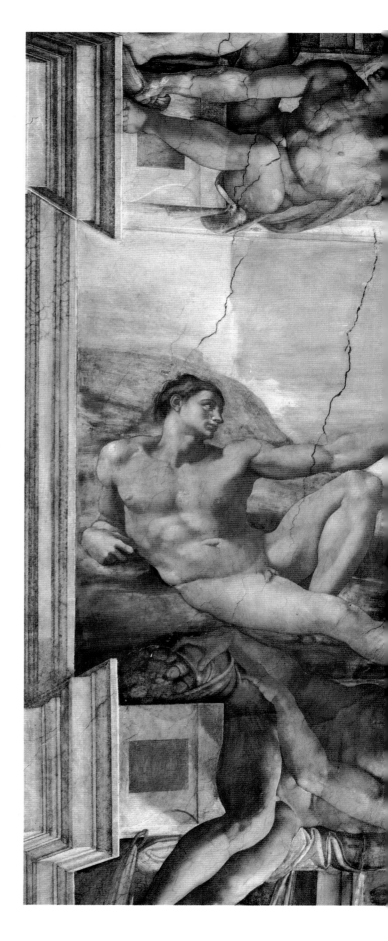

The Creation of Adam

MICHELANGELO, 1511. Sistine Chapel, Vatican, Rome.
This image of God is the perfect Renaissance blend of
realism and symbolism. The all-powerful God brings the
cloak of heaven toward earth where a barely animate
Adam reclines. The moment of creation is concentrated
at the smallest gap separating Adam from the finger of God.

wall tomb in San Pietro in Vincoli, Rome. Even so, Michelangelo's brilliant interpretation of the funerary tradition can be seen in a number of beautifully designed and executed tombs in the Medici Chapel for Giuliano and Lorenzo, and for the Duke of Urbino in the New Sacristy, San Lorenzo, Florence.

MICHELANGELO

The most influential artist of the High Renaissance was Michelangelo Buonarroti (1475–1564). Contemporaries were loud in their praises and frank in their imitation of his motifs and style, and subsequent generations of artists continued to turn to Michelangelo's techniques as exemplary.

Michelangelo was first and foremost a sculptor. He spent his formative artistic years under the patronage of Lorenzo the Magnificent, Duke of Florence. At this time, the Medici family included Giuliano, who would later rule Florence, and Giovanni, who would succeed Julius II as Pope Leo X in 1517. Michelangelo lived with the family and worked in an art school that had been established in the Medici gardens opposite the Church of San Marco. The young sculptor was able to study the great collection of the Medici family, which included works of ancient sculpture, cameos, medals, and Early Renaissance art.

Michelangelo worked differently from other master sculptors, such as Ghiberti and Donatello, who first created wax models and then added on material in order to bring out the effects of light and proportion. Michelangelo sculpted by carving away the marble surrounding the figure which he envisioned trapped inside.

While still in Florence, Michelangelo received his first commission from Rome for a sculpture for St. Peter's. *The Pietà* (1498–99) was acknowledged as an outstanding work from the moment it was revealed to

Moses

MICHELANGELO, c. 1515; marble. S. Pietro in Vincoli, Rome.

This statue was carved as part of Michelangelo's second design for Julius II's grand tomb. Such a dynamic figure was intended to be seen from below, but in the final version of the tomb the statue is set at eye level, distorting the superb shadowing effects.

Pietà

MICHELANGELO, 1498–1500; marble. St. Peter's, Vatican, Rome.

In this Pietà, Michelangelo expressed the emotional, human aspect of Mary mourning over the body of her dead son. The figures are realistic yet highly idealized, as revealed in Mary's youthful appearance and her larger scale, which allows Christ's body to gracefully fit upon her lap.

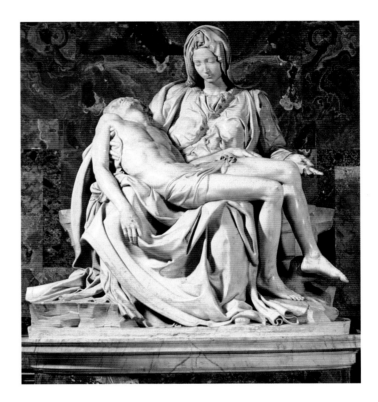

a crowd gathered in St. Peter's. Michelangelo never signed his sculptures, so people immediately began to speculate as to the identity of the artist. According to Vasari, Michelangelo went back later that night and carved his name into the sash that crosses the Madonna's chest.

After Michelangelo was called to Rome in 1505, he worked for a few years on the papal tomb until Julius II temporarily put a halt to the expensive project so that the rebuilding of St. Peter's could begin. While Julius II led the Italian armies against the French who were attacking in Bologna, he ordered Michelangelo to paint the ceiling of the Sistine Chapel. The nine scenes from Genesis took almost four years to complete (1508–12) and the work was done primarily by the artist himself. This was unusual in an age when

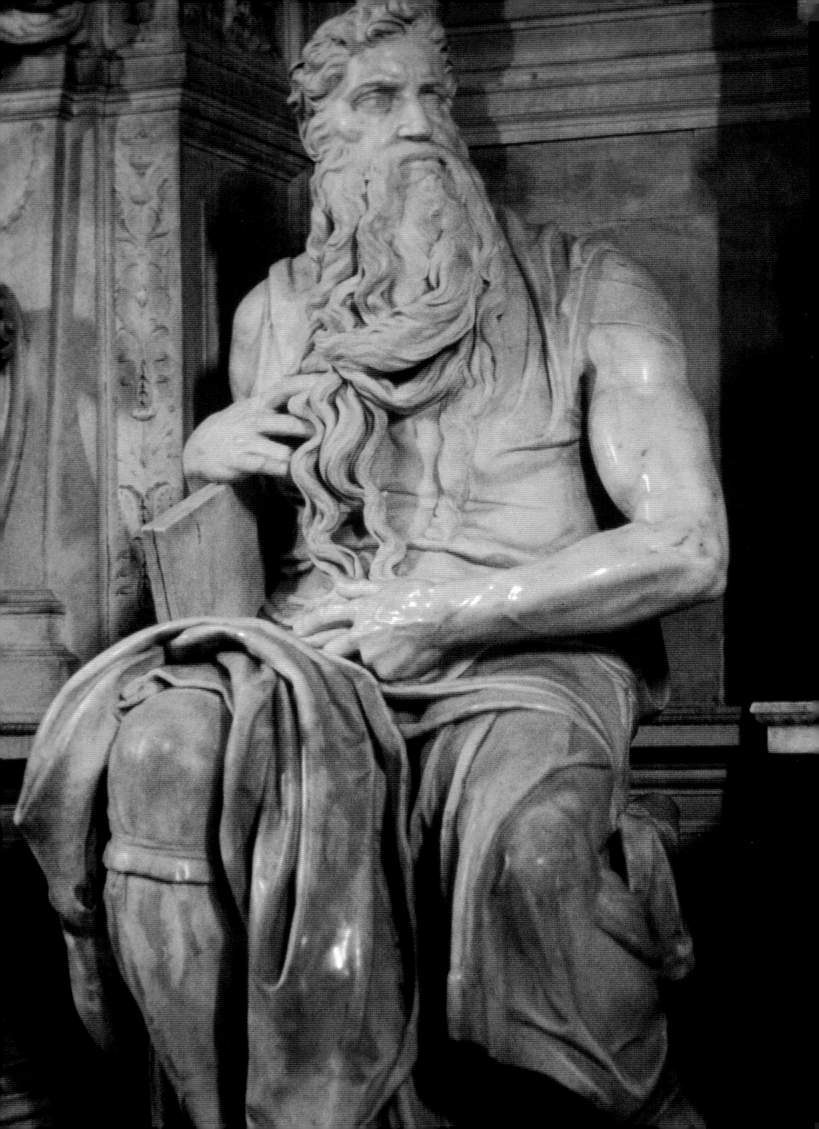

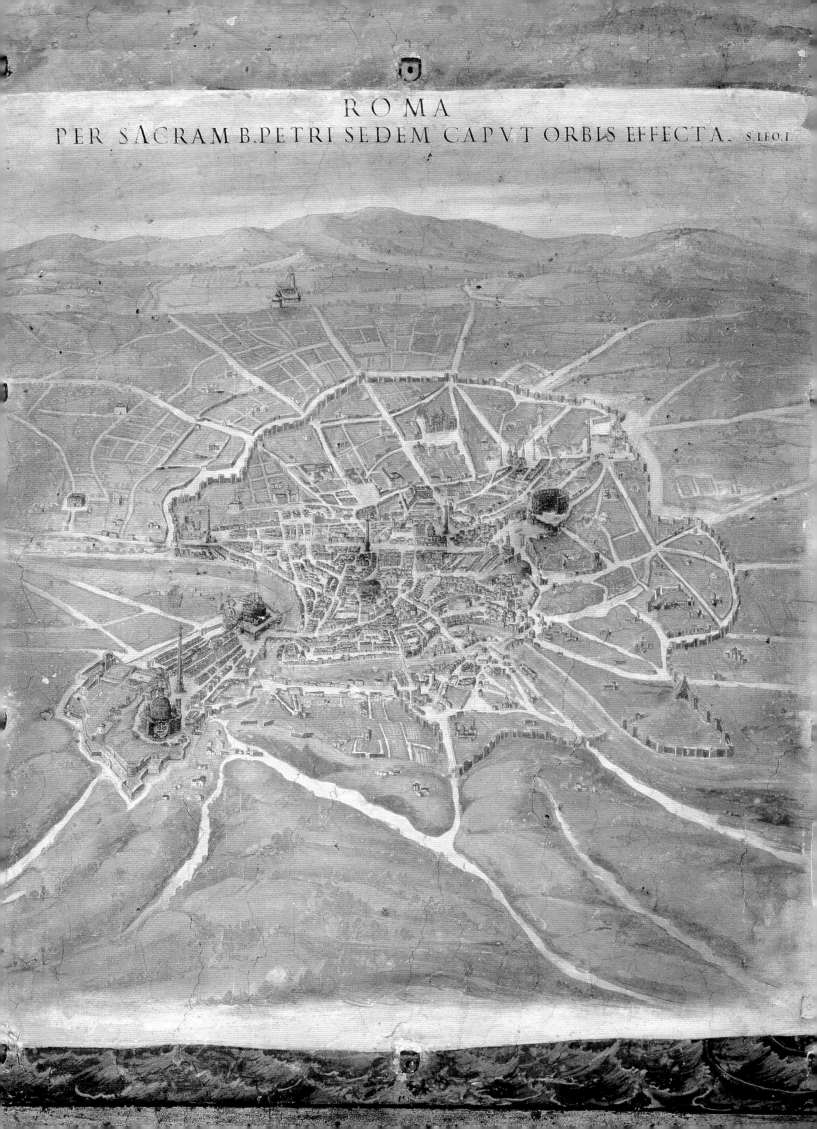

ROMA
PER SACRAM B.PETRI SEDEM CAPVT ORBIS EFFECTA. S.LEO.I.

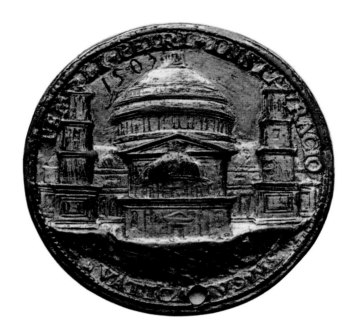

Medal

BRAMANTE's design for the new St. Peter's Christoforo Foppa Cardossa, 1506; bronze. British Museum, London. Commemorative medals, inspired by ancient Greek and Roman coins, were eagerly collected by patrons. The reliefs are often portraits of rulers, but important events and structures were also cast.

With the papal court as the dominant patron in Rome, many of the extraordinary works of the High Renaissance were commissioned for churches and religious decoration. Some of the most extraordinary sculpture of the Renaissance was created for tombs. Funerary monuments were a tradition of Christian art that went back to the second century A.D., when Roman sarcophagi were the first sculptural works to mimick classical mythological patterns within a Christian context.

Renaissance tombs can be found in basilicas and cathedrals throughout Europe. Usually the deceased was portrayed as a recumbent effigy on the lid of the tomb. Gradually tombs acquired elaborate architectural settings and were adorned with figures of allegorical virtues and legendary heroes.

This centuries-old tradition was raised to new heights by Michelangelo when he was called to Rome in 1505 by Pope Julius II to design his tomb. Scholars believe it was the inspiration of Michelangelo's grand free-standing tomb—two stories high with dozens of statues and an ornate sculptural bier—that inspired Julius II to tear down the old basilica so a new, larger St. Peter's could be built to house his funerary monument.

Work on Julius II's tomb turned into decades of on-again, off-again frustration for Michelangelo, as it was progressively downscaled to a comparatively modest

fanned out from the Piazza del Popolo. His architects even plundered stone from the Colosseum to build a new bridge over the Tiber that could ease congestion from visiting pilgrims.

Thus the stage was set for the emergence of High Renaissance patrons. Pope Julius II (1503–17) was a tireless patron, and usually had several major projects in progress simultaneously. Like Sixtus IV, Julius was also a major military commander, and set about protecting the entire Italian peninsula against French and Spanish invaders. He made the borders of the papal states so secure as to seem impregnable.

The brief period of the High Renaissance was infused with a sense of grandiosity that was not seen in the earlier Florentine work. Pope Julius II undertook to rebuild St. Peter's in Rome in a leap of unprecedented daring and disregard for tradition. The ancient church had housed the shrine of St. Peter for centuries, and the site was considered to be consecrated by generations of ecclesiastics.

Julius II prevailed in his grand scheme, however, and by 1506 the old basilica of St. Peter's had been torn down and foundation stones laid for the new piers of the crossing. The project was popular among the craftsmen of Italy because it employed more than 2,500 workmen. (Ironically, this magnificent display of papal devotion would later help spark the Reformation, dividing Christendom forever over theological questions of the price of redemption.)

Street Plan for Rome

DANTI IGNAZIO, c. 1590. Biblioteca Apostolica, Galleria delle Carte Geografiche, Vatican, Rome. The great Aurelian Wall from the third century A.D., which can be seen in this bird's-eye view, encloses a much larger area than was inhabited during the Renaissance. The unfinished basilica of St. Peter's is on the lower left-hand side.

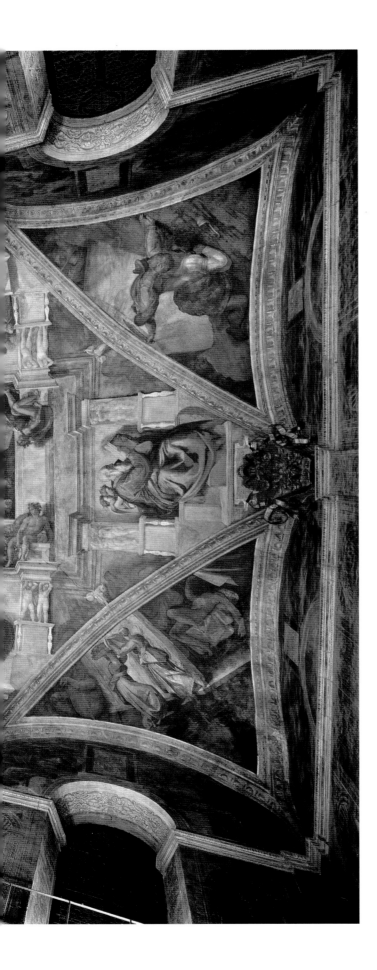

THE HIGH RENAISSANCE

For one hundred years, Florence had ruled as the city of innovative art, dazzling visitors with its modern magnificence. Indeed, Michelangelo and Leonardo da Vinci, the two major artists of the High Renaissance, called themselves Florentines even though they spent the greater part of their lives working in Rome. This was due to the fact that from 1495 until the sack of the city in 1527 Rome became the center of Renaissance art and architecture.

Pope Sixtus IV was the first to truly defend the papal states against the stronger city-states of Florence and Venice. Between 1471 and 1484, he gained power through a combination of political maneuvers and nepotism that established a loyal network of nobles. Above all, Sixtus IV was a patron of letters and the arts. His monumental undertakings included the construction of the Sistine Chapel and the restoration of ancient monuments, which he ordered to be moved to positions of prominence. The obelisk imported by Nero for his ancient circus now sits in the center of the plaza of St. Peter's.

As always, however, improvement had its cost. Sixtus IV also ordered the destruction of many existing structures, including those that had survived from antiquity, in order to create three straight streets that

The Ceiling of the Sistine Chapel

MICHELANGELO, 1508–12. Sistine Chapel, Vatican, Rome.
When the first section of scaffolding was taken down, Michelangelo realized that the figures were too small. As a result, beginning with the Temptation and Expulsion, he enlarged and simplified the scenes.

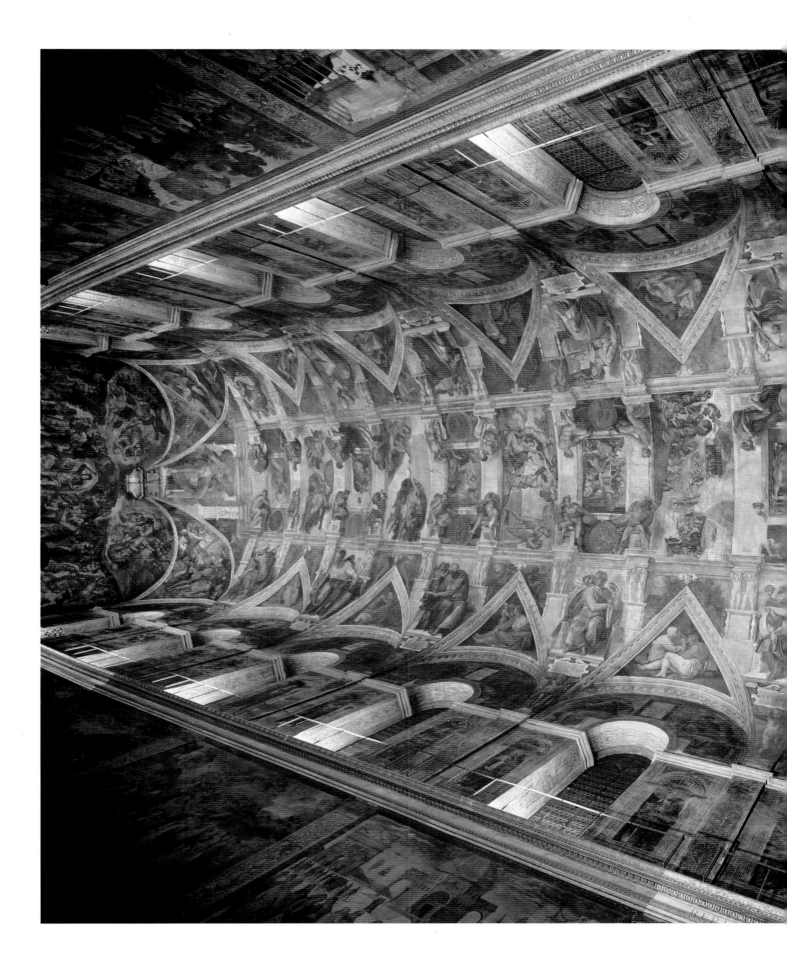

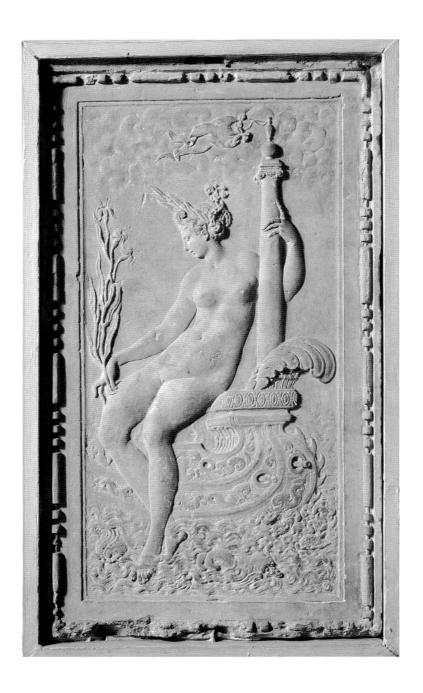

The Nymph of the Seine

JEAN GOUJON, 1548–49; bas-relief. The Louvre, Paris.

Even Goujon's rather flat reliefs, with the new Renaissance

techniques in sculpture as applied here, appear fully three-dimensional.

The Sacrament of the Eucharist

ROGER VAN DER WEYDEN, 1437; oil on panel. Royal Museum of Fine Arts, Antwerp. Van der Weyden chose to highlight only those gestures and features that expressed the emotional impact of the biblical narrative. For thirty years he was the premier painter in Brussels, influencing generations of artists, including those in France and Germany.

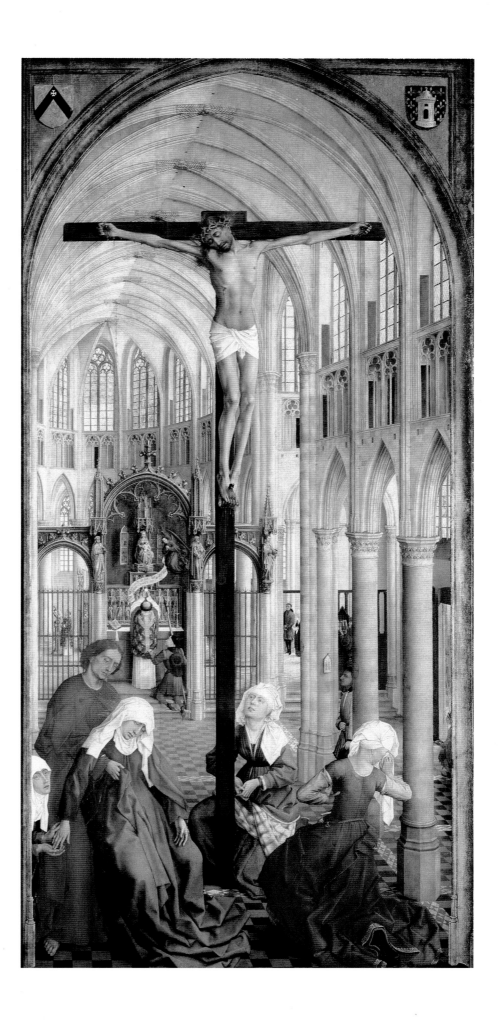

The Portinari Altarpiece

HUGO VAN DER GOES, c. 1476; panel; center: 8 ft. 3½ in. x 10 ft.; wings: 8 ft. 3⅛ in. x 4 ft. 7½ in.
(center: 252.7 x 304.8 cm; wings: 251.7 x 140.9 cm). Uffizi Gallery, Florence.

Hugo van der Goes worked in the busy city of Bruges; tragically, however,
he ended his own life at the age of forty-four shortly after retreating
to a monastery. He varied the scale of figures and objects for expressive
purposes yet was meticulous about the natural appearance of landscapes
and plants, as well as the gestures and expressions of his figures.

close commercial ties to Venice, and to the Neo-Platonic academy of Florence. Dürer was one of the first northern artists to travel to Italy (in 1495) to study the art of the Early Renaissance. Ten years later he again visited during his extensive travels through Europe. In his lifetime, Dürer was a well-known and admired artist with a reputation that was second only to Leonardo da Vinci. The artist's theoretical treatises on perspective, architecture, and human anatomy as well as his natural history studies rival those of the best scholars of the High Renaissance.

Dürer's well-deserved fame rested in part on the success of his favorite medium—engraving. Trained as a goldsmith, he was unusually dexterous with the tools that were used to produce woodcuts and engravings. To produce an image, the artist must force a sharp burin across the wood or metal, carving out a groove. The surface that is not cut away will transfer the ink onto paper. Dürer's strength and control in this medium is clear in the formation of tiny parallel lines.

Dürer was considered to be the artist of "everyman." He illustrated books for numerous printing presses and he sold individual prints on sheets of paper which even the average person could purchase. Early in his career, he made a set of fourteen large woodblock prints illustrating the Revelation of St. John, the last book of the Bible. Using the engraving technique of hatching lines, Dürer developed a shading effect and tones of gray not seen before, or since, in wood carving.

In his engraving of *Adam and Eve* (1504) Dürer combines technical skill with an understanding of Italian Renaissance ideals. The figures pose in an attitude reflecting the Apollo Belvedere and the Medici Venus, two popular Hellenistic statues which were often reproduced in contemporary prints.

Dürer's figures are idealized with perfect proportions: the Italian dictates of Vitruvius, for example, are clear in the figure of Adam. However the northern influence is apparent in Eve, a softer, rounder woman than those representing the Italian ideal, resembling nothing less than a plump German matron. Dürer's ability to suggest a monumental grandeur while retaining the authenticity of his scenes and subjects places him wholly in the class of High Renaissance artists.

Adam and Eve (The Fall of Man)

ALBRECHT DÜRER, 1504; engraving;

10 x 7½ in. (25.4 x 19 cm). Philipps University, Marburg.

As the snake passes the apple to Eve, the fall of man from God's grace is symbolized as well by the face-off between the mouse and the cat in the foreground. A more scientific allusion is made via the background animals, which represent the four humors of man believed to govern health.

The Great Piece of Turf

ALBRECHT DÜRER, 1503; watercolor; 16 x 12½ in.

(40.6 x 31.7 cm). Graphische Sammlung Albertina, Vienna.

For both Dürer and Leonardo da Vinci, direct observation was the path to truth. Modern scientific methods of perfecting the examination of the physical world led to inventions—from telescopes to microscopes—that would improve and enhance man's sight.

development of entirely new genres in painting, such as landscape, still life, and small domestic scenes.

Printing was key to the success of the Reformation. Not only could vernacular Bibles be made cheaply for the masses, but printed pamphlets too were ideal for conveying the theological arguments of the Protestant leaders. Even the poorest people could understand the graphic illustrations in the pamphlets portraying greedy churchmen fleecing the needy so that their crosses could be gilded with gold and their tables covered in rich foods.

ALBRECHT DÜRER

Albrecht Dürer (1471–1528) was the best known artist to combine forms and ideals from both northern and southern Europe. Dürer's work often had a religious content, and as a young artist he was employed by the papacy. Yet by the time of his death, Dürer was a staunch supporter of the Reform.

In Germany, the wealthy merchant class maintained

Melancholia

ALBRECHT DÜRER, 1514; engraving; 9½ x 7½ in. (24.1 x 19 cm). Philipps University, Marburg.

There are so many references and allusions in this complex engraving that the meaning is difficult to interpret. Yet every detail, from the scales that hang in balance to the etched feathers on the wings, is a testimony to Dürer's talent and dexterity.

Self-Portrait

ALBRECHT DÜRER, 1500; oil on panel; 26¼ x 19¼ in. (66.6 x 48.8 cm). Pinakothek, Munich.

Dürer was one of the first artists to leave behind a series of paintings of himself. These detailed self-portraits record the relentless passage of time, marking not only physical changes in appearance but the development of artistic skill.

1500

AD

Albertus Durerus Noricus
ipsum me propriis sic effin
gebam coloribus aetatis
anno XXVIII

interpret the word of God for themselves. (Not until the eighteenth century did the Catholics approve an Italian translation of the Latin Bible.)

By the time the lengthy Council of Trent (1545–63) was completed, over half of Europe—particularly in the north—was following the lead of the Reformation. Protestant iconoclasm quickly strangled religious art in Northern Europe and inspired the rapid

The Crucifixion, from The Isenheim Altarpiece

MATTHIAS GRÜNEWALD, c. 1510–15; oil on wood; center panel: 8 ft. 10 in. x 10 ft. 1 in. (269.2 x 307.3 cm). Musée Unterlinden, Colmar. Grünewald stringently pursued the mastery of figural anatomy even in his religious paintings. The symbolic, storytelling elements include the figure on the right: St. John the Baptist pointing out the theological meaning that Christ must die so that man can be saved.

of St. Anthony of Isenheim, and the exaggerated suffering of Christ was considered a fitting subject to be viewed by mortally ill patients and hardened doctors. Indeed, those who knew real suffering would not be comforted by a serene abstraction of the torture of crucifixion.

The altarpiece has two pairs of hinged panels flanking the Crucifixion that are painted with representations of saints. When these panels are open, Grünewald's masterpiece, the Resurrection, is revealed. The spirit of triumph is stunningly conveyed through the burst of divine light that overcomes all those nearby. Though the figure of Christ floats in the air, his stance seems solidly braced against the drapery which rises like a twisting column from the sarcophagus.

Color and expressive gesture are the dominating factors in Grünewald's work, and not the physical forms or composition. To Italian artists, the Isenheim Altar would have seemed undisciplined and ungraceful; in much the same way would Mannerist designs be viewed following the Italian High Renaissance.

THE REFORMATION

Ironically, the Protestant Reformation was born out of the theological wrangles during the Great Schism, when the Church Councils of the early fifteenth century were determining the legitimate descent of the papacy. At first, church reformers criticized a few of the more objectionable contemporary practices.

Then in 1517 a St. Augustine monk, Martin Luther, publicly protested the sale of indulgences—documents that officially granted absolution for sins, whether the person was dead or alive. As long as they had enough money, anyone could buy indulgences for a number of criminal and immoral acts.

Luther's attack on ecclesiastical abuses came on the heels of Pope Leo X's campaign to increase the sale of indulgences. The new pope had just been elected after the death of Julius II, and like his predecessor, Leo X needed vast sums to continue the construction of the new St. Peter's basilica in Rome. Needless to say, the upper ranks of ecclesiastics were in favor of generating extra revenue by the sale of indulgences. Luther continued to expose a doctrine of "justification by faith" alone, while John Calvin, a French theologian, published a systematic manual of Protestant theory in 1536 that broke decisively with Catholic dogma.

To these leaders of the Reformation, worshipping Mary, the Apostles, and the ever-increasing number of saints was akin to paganism. They believed in the scriptural dictate that man was to worship the one God, and that if any personal salvation could be won, it was by internal faith rather than outward, costly devotions.

The Protestants (from "protest") did away with the jewel-encrusted shrines and paintings, in keeping with the Old Testament law condemning the religious use of images. Under Protestant rule, monasteries were disbanded and their wealth seized. Prayers for souls in purgatory were considered useless since only the individual himself could influence his state before God, and only two of the holy sacraments were considered to be ordained: baptism and holy communion.

The populous usually followed the spiritual lead of their rulers, and this caused some bloody battles during the following centuries as politics and religion became hopelessly entangled. Henry VIII's defection from the Church is notorious for its basis in personal and political reasons rather than theological beliefs: the king, of course, needed to divorce Catherine of Aragon in order to marry Anne Bolynn. Even more important, by establishing himself as the head of the Church of England, Henry VIII was able to directly confiscate the lands and money of the numerous monasteries in England.

The first wave of humanist study and exploration had barely hit the north, with Greek translations readily available only by 1500, when it was overrun by questions raised by the Reformation. The Dutch scholar Erasmus translated the New Testament into Latin, while Luther and William Tyndale each created versions of the Bible in their native languages (German and English). These widely read vernacular texts had the most powerful influence on the Reformation movement, since any lay person could now read and

1612, was the greatest collector of his day, surpassing even Cosimo de' Medici. His books, paintings, and engravings represented a wide range of scientific and social interests. He named Johannes Kepler his imperial astronomer and supported the discovery of the elliptical orbits of the planets around the sun—the key to finally understanding the complex movements of the stars through the sky.

Matthias Grünewald

During the sixteenth century, northern painters often used symbolic detail for moralizing purposes. Along with the great Flemish master Pieter Bruegel the Elder, two other painters emerged who attempted to instruct and inform their viewers: Hieronymus Bosch and Matthias Grünewald. Bosch's *Garden of Earthly Delights* (1505–10) involves swarms of nude figures cavorting in a bizarre, panoramic landscape. Bosch mixed his version of medieval grotesques and Flemish proverbs into an intriguing allegory of man's base nature, which could run amok if not properly cared for.

Matthias Grünewald was probably influenced by Bosch's distortion of natural shapes in order to convey heavenly or evil influence. Shortly after being taken on as court painter, architect, and engineer for the archbishops of Mainz in 1511, Grünewald painted the repellent and unforgettable Isenheim Altar. The altar was commissioned for a monastic hospital, the order

The Resurrection, from The Isenheim Altarpiece

MATTHIAS GRÜNEWALD, c. 1510–15; oil on wood; center panel: 8 ft. 10 in. x 10 ft. 1 in. (269.2 x 307.3 cm). Musée Unterlinden, Colmar.

The Reform movement would often interpret the Scriptures fairly literally, as did Grünewald in this representation of Christ, whose "countenance was changed and his raiment became radiant white."

Garden of Earthly Delights

HIERONYMUS BOSCH, c. 1505; oil on wood; triptych: left panel,
Garden of Eden; *center panel,* The World Before the Flood;
right panel, Hell; *side panels: 86 x 36 in. (218.5 x 91.5 cm),*
center panel: 86 x 76 in. (218.5 x 195 cm). Prado, Madrid.
Monks in their scriptoria often painted monstrous little
figures in the margins of biblical texts. Scholars are not
certain whether these grotesques were created out of
whimsy or for instructional purposes—just as the exact
meaning of Bosch's intricate allegories also have been lost.

men pictured are Jean de Dinteville, French ambas-
sador to England, and Georges de Selve, French
ambassador to the Imperial Court. To show they were
cultured men, the symbols of music (a lute, a bag
of flutes) and science (globes, a sundial, a quadrant,
a polyhedron) are well represented. Mortality
is uniquely signified by a skull slanting across the
foreground (best seen at an angle from the right).

Germany, like Italy, was divided into a number of
small territorial states. The Habsburg family became
one of the principal sovereign dynasties of Europe (the
House of Austria). The Habsburgs successfully im-
posed hereditary descent over a vast private empire
that included territory in Germany, the Netherlands,
and Spain.

Because of their vast lands and holdings, the elec-
toral college of the Holy Roman Empire (consisting of
three archbishops and four German princes) ap-
pointed Frederick III, the Habsburg king of Germany,
as Holy Roman Emperor in 1452. Notable Habsburg
rulers included: Maximilian I, elected emperor in
1493; his grandson Charles V, 1519; Charles's brother
Ferdinand I, 1558; and Ferdinand's son Maximilian II,
1564. These men were cultural as well as political
leaders and they poured huge sums of money into
artistic and scholarly pursuits.

One of the latter Habsburg emperors, Rudolf, son of
Maximilian II and the ruler of Bohemia from 1575–

The French Ambassadors

HANS HOLBEIN THE YOUNGER, 1533; oil and tempera on wood; 6 ft. 8 in. x 6 ft. 9½ in. (203.2 x 207 cm). National Gallery, London.

For centuries courts communicated with each other through diplomatic representatives,

but it became a practice during the Renaissance to establish resident ambassadors. These

men of learning were instrumental in spreading the classical developments in art and philosophy.

THE SIXTEENTH CENTURY

The Renaissance was a turbulent age in Northern Europe as various territorial disputes were settled, roughly establishing the independent nations of the modern age. By the beginning of the sixteenth century most of the formerly free trade cities of the north had fallen under the control of powerful rulers.

Spain (with the exception of the Moorish kingdom of Granada, conquored in 1492) was united by the

The Escorial

King Philip II of Spain commanded architects Juan Bautista de Toledo and Juan de Herrera to design a structure that was "simplicity of form, severity in the whole, nobility without arrogance, and majesty without ostentation."

The Château of Chambord

The unity of the surrounding square fortress on the Loire River in France is echoed by the horizontal levels of the Château with its rows of symmetrically placed windows. Yet the cluttered roof-line of pointed spires, chimneys, and cupolas is typically Gothic.

marriage of Ferdinand and Isabella in 1469, though then as now Portugal remained an independent country. Poland declared itself an elective monarchy in 1572, and the rich lands of England and France each were gradually unified under one king. France finally won Calais back from the English in the early sixteenth century, while England annexed Scotland at the close of the Renaissance era, in 1603.

The increasing strength and position of the French and English monarchies made their courts desirable places for artists to work. There was an ongoing exchange of skills as many northern artists traveled to Italy to study Renaissance methodology firsthand, while Italian artists were increasingly hosted by foreign courts. The French king, Francis I, invited both Cellini and Leonardo da Vinci to stay at Fontainebleau. In England, Henry VIII employed a series of Italian artists including Pietro Torrigiano and Benedetto da Rovezzano.

Out of Italy came the idea that statesmen and affluent tradesmen could have palaces as impressive symbols of power; royalty too strained to reach new standards of opulence. Francis I built a series of palaces including the Château de Chambord (1519) and the Louvre (commissioned in 1546). Henry VIII openly competed with Francis I when he built the Nonsuch Palace in Surry (begun in 1538). But none could rival Philip II of Spain, who commissioned Juan Bautista de Toledo and Juan de Herrera to build the Escorial (1563–84). The Escorial was a vast complex that combined a palace, a cathedral, and a monastery in unifying classical architecture. The Escorial owes its form to Vitruvian descriptions of architecture, and to the Temple of Solomon.

Personal residences did not change much in design, but Renaissance façades were often added to ordinary structures to make them more fashionable. New construction was designed first by architects rather than being left to the builder's imagination, and blueprints and floor plans were drawn up for contract approval by the client.

In painting, the northern love for symbolic detail persisted throughout the sixteenth century, as in Holbein's *The French Ambassadors* (1533). The two

Since much of the wealth and power was distributed among the Flemish bourgeoisie, artists tended to work for their fellow citizens rather than the aristocracy. This new empowered class of burghers wanted realistic portraits of themselves. Northern artists had to walk a fine line, painting a recognizable likeness that emphasized the patron's better qualities. Jan van Eyck's portrait of Canon van der Paele (1436) is quite realistic, right down to the wrinkled jowls and balding head. Even the hands appear veined and old.

Perhaps the best known portrait by van Eyck was commissioned by an Italian merchant of the Arnolfini family. This portrait of the wedding couple follows the Flemish tendency to focus on the nuclear family rather than extended relations (like the aristocratic Medici family). Among the middle class, weddings were made by personal preference instead of as political alliances.

In the mirror, Jan van Eyck painted his own portrait along with that of another person, indicating they were witnesses to the ceremony. Van Eyck even signed over his image "Jan van Eyck was here." This literal translation of the nuptials is further carried to the couple's bare feet, indicating they stand on holy ground during the consecration of their vows. The little dog in the foreground is a symbol of loving fidelity.

PIETER BRUEGEL

Pieter Bruegel the Elder was the last great Flemish master. With true humanist resolve, he painted what he believed to be the true condition of man, at the mercy of the unpredictable and all-powerful forces of nature.

Bruegel was considered to be a satirist. Many of his paintings can be misinterpreted as simple festival scenes. But on closer examination the dancing peasants with their kicking heels are obviously caricatures

The Return of the Hunters

PIETER BRUEGEL THE ELDER, 1565; oil on wood; 46 x 64 in. (116.8 x 162.5 cm). Kunsthistorisches Museum, Vienna.

Bruegel painted six scenes illustrating the seasons. In this painting, the winter snow shrouds a Flemish countryside that curiously abuts the jagged cliffs of the Alps. The painter defies the dictates of realism in order to solve the compositional need to balance the white diagonal mass of the hillside in the foreground.

of boisterous fun. In *The Battle Between Carnival and Lent* (1559) the small group of penitent Christians in their brown robes are overpowered by the rollicking, riotous crowd that is enjoying carnival. Bruegel was among those who believed that festivals were simply an excuse for drunken, uncontrolled behavior.

Bruegel spent a few early years in Italy studying art, but his paintings are better known for their expression rather than proportion of line and mass. Even in his series of six paintings that beautifully commemorate the seasons, Bruegel made it clear that he chose to represent the peasant class because they were most affected by the seasonal changes.

Giovanni Arnolfini and his Bride

JAN VAN EYCK, 1434; tempera and oil on wood; 32 x 22 in. (81.2 x 55.8 cm). National Gallery, London.

Jan van Eyck's compositions sometimes have a rigid, static quality because of the precision of his textural surfaces. Concrete detail, however, was admired in a picture that served to document Arnolfini's wedding, just as a twentieth-century marriage license would.

FOLLOWING PAGE

The Battle Between Carnival and Lent

PIETER BRUEGEL THE ELDER, 1559; oil on oakwood; 46 x 64 1/8 in. (118 x 164.5 cm). Kunsthistorisches Museum, Vienna.

Near the end of his life, Bruegel destroyed the inscriptions that originally accompanied his paintings and prints because he believed them to be too bitter and sharp in their satire. Thus it is left to the viewer to interpret each scene.

The Ghent Altarpiece

JAN VAN EYCK, 1432; tempera and oil on wood;
11 ft. x 7 ft. 3 in. (335.2 x 220.9 cm). St. Bavo, Ghent.
The central body of this enormous altar has
two hinged wings that close to reveal a scene
of the Annunciation. In all, there are twenty
panels of varying shapes and sizes which van
Eyck treats as niches to hold his sculptural figures.

Christian devotion. Flemish painters believed that the best way to approximate God was via the power of sight, for it was understood He could see everything, great and small. Thus each detail reveals the divine presence by its very existence.

Jan van Eyck

Jan van Eyck is often credited with being the first painter to use oil pigments, but the Master of Flemalle's Merode Altarpiece was completed four years before the Ghent Altarpiece (1432), the first work that can be definitively attributed to van Eyck. The style of van Eyck's altarpiece is very similar to the Merode Altarpiece: both have spatial depth and sharply shadowed folds of drapery that suggest volume much better than the looping, curving lines in medieval illuminations.

The space is loosely organized by conflicting vanishing points, yet van Eyck produces a splendid illusion of diminishing distance in the landscape through his use of atmospheric perspective. Background detail, such as the castle and mountains, are blurred by a blue-gray haze. The colors seem to merge into shadowy masses in exactly the same way that dust in the air obscures our view of distant objects. This could only be done convincingly with oil-based pigment, which allowed the artist to apply semi-translucent layers of different tones.

Northern artists applied Renaissance realism to every aspect of their paintings, especially in their portraiture. Before 1420 most painters limited themselves to profile views that were usually done on altarpieces to commemorate the donors. These donor portraits increased in size and prominence until the portrait became an independent genre.

Though portrait busts were common from the Roman era, there were no painted portraits for artists to study. The Italians preferred the profile view throughout the Early Renaissance, while the Flemish artists quickly mastered the full-face and three-quarter views. Many artists, from Holbein to Piero della Francesca, produced memorable miniature portraits.

Organ from The Ghent Altarpiece

Jan van Eyck, 1432; tempera and oil on wood; 11 ft. x 7 ft. 3 in. (335.2 x 220.9 cm). St. Bavo, Ghent, Belgium.

Van Eyck creates the illusion of depth through intricate patterns in the floor and robe, and in the shine of gold on the organ pipes. Upon closer examination, there are different vanishing points for the floor tiles as compared to the organ.

Saint Barbara

ROBERT CHAMPIN (Master of Flemalle), c. 1438;

tempera and oil on wood; 39³/₈ x 18¹/₄ in. (101 x 47 cm). Prado, Madrid.

Flemish painters were the first to experiment with three-dimensional representation. Though Champin was not familiar with the Italian technique of perspective, he successfully created a tangible depth through the physicality of the objects.

north was devoted to religious subjects, as northern artists experimented with increasingly realistic detail and the optical illusions of atmospheric perspective.

In France, artists were employed by the secular courts of the dukes of Berry, Bourbon, and Nemours. These artists followed the lead of the Flemish masters, especially in the development of realistic portraiture, but they were slower to master the use of oil paints. German artists were deeply under the influence of the Flemish masters, and they continued to emphasize the flamboyant Gothic forms and frieze-like compositions of the middle ages. By the middle of the fifteenth century, the influence of the Flemish masters had spread as far south as Spain.

ROBERT CHAMPIN

The Flemish artist Robert Champin (often referred to as the Master of Flemalle) was the first to switch from egg-based paint to oil-pigments. Subsequent generations of Flemish artists would learn oil painting while training in the well-organized art guilds. Young artists started at the bottom, learning how to mix colors and varnishes, and performing the lesser tasks required by their painting master.

The oil medium gave northern paintings a rich luminous surface and depth of reflected light that tempera-based pigment lacked. Compared to the northern Renaissance paintings, the Italian works—despite their technical skill—retained a rather flat, patterned surface.

Saint Barbara (c. 1438), by the Master of Flemalle, retains the medieval convolutions of linear perspective. Yet this work embodies the Renaissance ideals of realism in the forms and textures of the objects. Shadows carefully imitate the slanting sunlight into a room, and the colors are subtle and vary in tone to indicate volume and mass, unlike the stylized flat planes of color found in medieval painting.

Indications of Renaissance humanism also appear in the details of the scenes. The tower of St. Barbara is cluttered with everyday objects from a typical middle-class Flemish home, and the chalice, the wafer, and the peacock feather are all symbols of St. Barbara's

The Northern Renaissance

Medieval traditions lingered into the fifteenth century in northern Europe, influencing the development of Northern Renaissance art and architecture. Northern artists often combined Renaissance techniques of perspective and realism with typically Gothic elements, such as pointed arches and the meticulous detail usually found in manuscript illumination. This blend of medievalism and Renaissance realism is exemplified by the gorgeous illustrations in the Limbourg Brothers' Book of Hours for the Duke of Berry, brother of the king of France and Philip the Bold of Burgundy. The Book of Hours contained eight liturgical passages, from Matins to Compline, which were supposed to be read throughout the day. The Limbourg Brothers enlivened this religious text with aristocratic scenes of pleasure.

The Italian style of Renaissance art was carried by merchants and foreign businessmen into the north.

The Flemish cities of Tournai, Ghent, and Bruges were centers of international commerce. Bruges rivaled Florence in its wealth derived from the wool trade and international banking. The Duke of Burgundy made Bruges his capital and, from the early fifteenth century, the city was the home of the most powerful rulers in the north. Through marriage, the Dukes of Burgundy controlled the Low Countries and lands that stretched from the Rhône River to the North Sea.

This kingdom lasted until the death of Charles the Bold in 1477. Then Maximilian of Habsburg married Mary of Burgundy, taking the Netherlands under the rule of the Holy Roman Empire and allowing the French to annex the southern lands.

Flemish painters were relatively uninspired by the mythological subjects and classical symmetries of Italian art. Most of the Early Renaissance art in the

Plan of the World

Paolo Toscanelli, c. 1450s; tempera on parchment. Biblioteca Nazionale, Florence. This view of the world was created before the great sea voyages that would lead Europeans to discover the western hemisphere. Note that Italy is shown at the center of the world.

Les Très Riches Heures du Duc de Berry

The LIMBOURG BROTHERS, 1413–1416; illumination. Musée Conde, Chantilly. The pictures for this renowned Book of Hours are represented by seasonal tasks in each of the twelve months. In February a farmyard is shown, with the ground covered by snow and a peasant in the distance with a donkey pulling firewood toward the village; in May, a group of aristocrats ride out on their elaborately decked steeds to enjoy the spring festival. Shown here is the grape harvest, representing the month of September.

The Tomb of Leonardo Bruni

BERNARDO ROSSELLINO, c. 1445;

colored marble. Santa Croce, Florence.

Throughout the middle ages and the Renaissance,
funerary monuments provided endless commissions
for reliefs on sarcophagi and simple tomb slabs
as well as magnificent architectural monuments.

Hercules and the Hydra

ANTONIO DI POLLAIUOLO, c. 1460;

panel; 6 ft.¾ in. x 4 ft.¾ in.

(184.7 x 123.8 cm). Uffizi Gallery, Florence.

Hercules was a popular figure during
the Renaissance because of his heroic
associations. The Florentine people
considered Hercules their special
protector, just as the Spartans revered
Ares, and the Athenians claimed Athena
as their patron goddess.

Equestrian Monument
of Gattamelata

DONATELLO, 1445–53; bronze.

Piazza del Santo, Padua.

The city-states of Italy hired
soldiers of fortune (*condottiere*)
to fight their battles rather
than maintaining standing
armies. These men were
considered heroes by grateful
citizens and were often
honored with life-size statues.

45

Ospedale degli Innocenti (Foundling Hospital)

FILIPPO BRUNELLESCHI, c. 1419–50. Piazza della SS. Annunziata, Florence.
Brunelleschi completed the plans for this foundling hospital
shortly before he won the commission for the dome of Florence
Cathedral. The series of round arches are supported by slender
columns, with the levels separated by strong horizontal entablatures.

Madonna and Child

FRA FILIPPO LIPPI, c. 1452; panel; diameter 53 in. (134.6 cm). Pitti Gallery, Florence.
Fra Filippo Lippi was a monk yet he interprets his subject in a rather worldly manner.
The interior is patterned on the home of a well-to-do Florentine, and scholars have
speculated that the identity of the model for the Madonna was Lippi's own mistress, Lucretia.

Portrait of Battista Sforza

PIERO DELLA FRANCESCA, after 1474; panel; 18¹/₂ x 13 in. (46.9 x 33 cm). Uffizi Gallery, Florence.
Portraits were extremely popular during the Renaissance, from full-length
figures on canvas to miniature reliefs on medallions. Couples often sat for
portraits shortly after their wedding, and royalty usually insisted on seeing
a portrait when considering an international alliance through marriage.

THE FALL OF FLORENCE

The popularity of a Dominican monk, Girolamo Savonarola, had a dramatic impact on Florentine society. Savonarola was a priest reformer who denounced the paganism of the Medici and their artists. Savonarola called on the citizens of Florence to repent of their opulent ways. When the Medici fled in the face of the invading French armies, Savonarola prophesied doom until the Florentines gave him control of the city. To maintain his power, Savonarola continued to blame the Medici for their corrupting influence which had invited foreign invasion. Savonarola officially banished the Medici from Florence, as well as the Tornabuoni and other wealthy, noble families.

Though Savonarola ruled for only five years (1494–98), the cultural life in Florence suffered a sharp decline without the patronage of the humanists. Yet the puritanical preachings of Savonarola would soon be echoed throughout Europe in the form of the Reformation, which effectively put a stop to the neo-pagan direction taken in the early years of Renaissance.

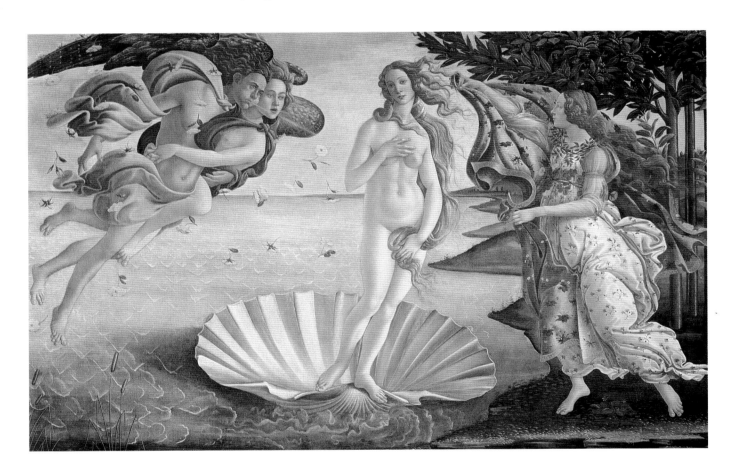

The Birth of Venus

SANDRO BOTTICELLI, c. 1482; oil on canvas;

5 ft. 9 in. x 9 ft. 2 in. (175.2 x 279.4 cm). Uffizi Gallery, Florence.

Renaissance palazzos (palaces) were lavishly decorated with frescoes on the walls and ceilings, usually depicting medieval romances or mythological scenes. This remarkable scene was painted on canvas, a material that was considered good enough only for temporary banners until the development of oil paints.

FOLLOWING PAGE:

Ceiling Fresco

ANDREA MANTEGNA, c. 1490s; fresco.

Ceiling of Camera degli Sposi, Palazzo Ducale, Mantua.

Mantegna often set himself challenging problems of perspective, balancing the need for a unified composition against the dictates of visual observation. In this fresco, he brilliantly relates the figures to the pictorial frame of the round ceiling.

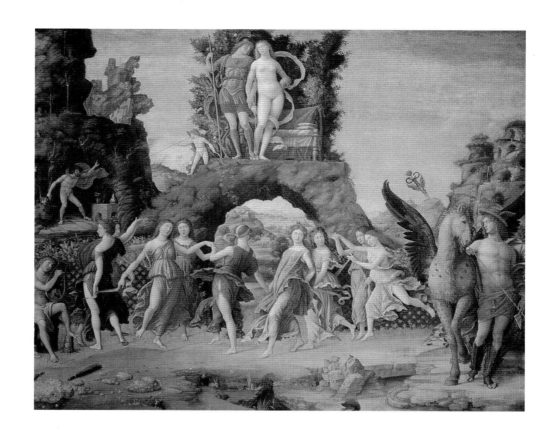

Parnassus

ANDREA MANTEGNA,
c. 1490; oil on canvas;
63½ x 75⅝ in.
(161.2 x 192 cm).
The Louvre, Paris.

This is a fully integrated classical fantasy, complete with lively interaction between the various gods and demi-goddesses, including the winged horse Pegasus, on the lower right.

MYTHOLOGY

Renaissance philosophers examined classical mythology and interpreted each story in the form of an allegory, attempting to reconcile pagan stories with the values of Christianity. In many Renaissance mythological scenes, the exact meaning is difficult to determine unless you know the allegorical associations. In Mantegna's *Parnassus* (1497), the allegory of love conquering war is symbolized by Mars and Venus at the top, with Vulcan, Mercury, Apollo, and the nine Muses dancing in the foreground.

Remarkably, it was very easy to reconcile the subjects of ancient mythology with the needs of the Church: Pope Alexander VI was associated with Alexander the Great, and Julius II was shown in the guise of Julius Caesar. As the supreme (and godlike) defender of the faith, popes often posed in the battle stance associated with Mars and Hercules.

In Botticelli's hands, the classical myth takes on a fresh appeal. His *The Birth of Venus* (1482) has many meanings and layers of significance beneath the well-known legend of Venus being blown by the Zephyrs to her sacred island of Cyprus. Botticelli's Venus is strangely weightless and mystical—the Platonic ideal of beauty rather than the sensual fertility goddess beloved by antiquity. This romantic vision of womanhood emerged from the chivalry of the middle ages. A Renaissance allegory was often made of the innocence of the human soul, vulnerable to the winds of passion unless protected by the cloak of reason.

Botticelli's nude Venus was just as remarkable as Donatello's David since the female nude was even more proscribed in the medieval era. Only the cloak of ancient mythology made Botticelli's presentation marginally acceptable. The artist was also fortunate in having the patronage of the Medici family, which allowed him to openly defy what amounted to a churchly edict against female nudity.

Botticelli was a pupil of Fra Filippo Lippi, and he adopted the monk's tendency to emphasize clear, hard outlines. He was the master of elegant, linear compositions which were vaguely medieval. Nothing could be more decorative than the foaming sea carrying Venus in a cockle shell while the nymph Pomona runs to meet her with a brocaded mantle. Such beautiful compositions with their lightly shaded tones, perfect for adorning villa walls, were in high demand by wealthy Florentines.

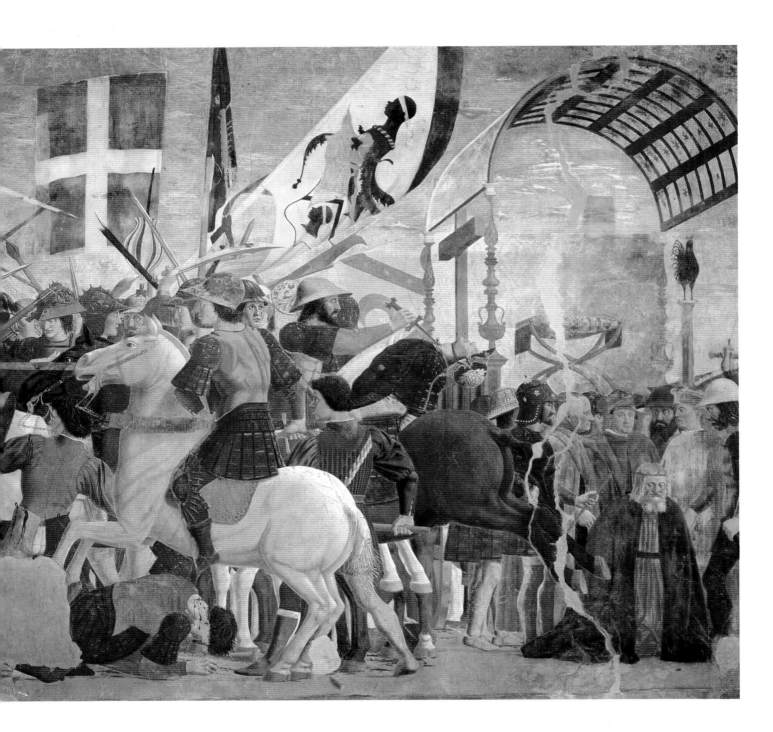

he is touched by a piece of the True Cross. All of these frescoes, including *The Battle of Heraclius and Chosroes*, contain many of the stylistic and scientific developments of painting that occurred during the Early Renaissance: a love for monumental compositions, and the use of perspective, proportions, light, and color to create realism in both figures and landscape.

The Battle of Heraclius and Chosroes

PIERO DELLA FRANCESCA, c. 1452–57; fresco.

From Legend of the True Cross, *S. Francesco, Arezzo.*

It is Piero's rational organization of space and distance that lends realism to these frescoes. Typical of the Early Renaissance, the expressions of the figures are calm and detached even as they engage in battle.

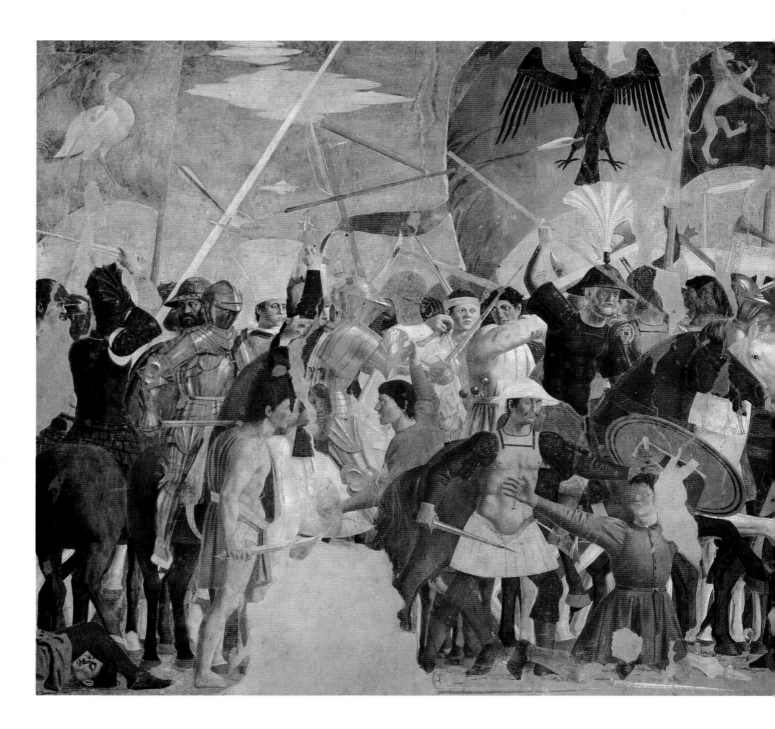

spaces. Piero had the mind of a mathematician, and he was the author of the first theoretical treatise on systematic perspective. He was particularly concerned with lighting, and he enjoyed teasing out subtle, repeating patterns in the poses of his figures and in architectural forms.

Piero's most important work was the fresco cycle he painted in the apse of San Francesco in Arezzo (1452–56), which depicts the legend of the True Cross in ten scenes. The legend of the cross on which Christ died was popularized in the *Golden Legend* by Jacobus de Varagine, a thirteenth-century version of the Scriptures. Piero's climactic scene, *The Proving of the True Cross*, is the moment when St. Helena, the mother of Constantine, witnesses the miraculous revival of a dead man when

The Tribute Money

MASACCIO, c. 1425; fresco.

Brancacci Chapel, Santa Maria del Carmine, Florence.

Masaccio, along with Brunelleschi and
Donatello, helped to formulate the principles
of perspective and foreshortening for genera-
tions of Renaissance artists. Vasari praised
Masaccio's ability to reproduce structures
and figures exactly as those created naturally.

The Battle of San Romano

PAOLO UCCELLO, c. 1445; panel; 6 ft. x 10 ft. 6 in.
(182.8 x 203.2 cm). Uffizi Gallery, Florence.

The constant warfare between ruling nobles led
to commissions for large, commemorative battle
scenes. Uccello, like most Renaissance artists,
chose a symbolic interpretation: the relatively
minor skirmish of San Romano resembles the
stately procession of a contemporary tournament.

PERSPECTIVE

The art of painting was transformed in the Early Renaissance by Brunelleschi's discovery of linear perspective, allowing painters to create a three-dimensional space on a flat plane. Along with linear perspective, the technique of atmospheric perspective was also developed to enhance the illusion of distance through light and color. Masaccio's *The Tribute Money* (c. 1425) is a perfect example of Early Renaissance exploration of atmospheric effects, with distance suggested by intensifying the blue tones of the background objects.

Renaissance artists moved away from the decorative surfaces of medieval paintings, which emphasized line, color, and gold leaf highlights. Lacking the technique of perspective, medieval artists simply stacked the figures on top of one another. Masaccio's figures, on the

other hand, seem to stand convincingly on the ground and move naturally as if on a stage.

One Florentine painter, Paolo Uccello, discovered perspective when he was a mature artist. He eagerly incorporated this technique into his medieval paintings with varying degrees of success. Uccello's *The Battle of San Romano* was painted for the Palazzo Medici to commemorate the Florentine victory over the Sienese in 1432. The surface decoration and the uptilted background evoke an earlier age of painting, but the composition is enlivened by the foreshortened lances and fallen soldiers. Uccello had a passion for creating geometrically solid forms.

Piero della Francesca was another Florentine painter who rose to the challenge of perfecting the appearance of geometrical forms and architectural

David

ANDREA DEL VERROCCHIO,
c. 1470; bronze. Bargello, Florence.
Verrocchio often competed
with Donatello; he also taught
many painters, including
Leonardo da Vinci. Clearly
Verrocchio has borrowed
Donatello's youthful inter-
pretation for his own *David*,
yet this pose is much more
open and dynamic, and the
anatomy is clearly defined.

David's seemingly innocent contemplation of his act, and the contrast between the youth's physical perfection and the ugly severed head, seems to capture the moment when a young man balances on the abyss of self-awareness. Thus Donatello expresses a humanist ideal in a way that transcends mere imitation of classical proportion and stance.

Painting

The artists of the Early Renaissance were jacks-of-all-trades, and this was true of painters as well as sculptors and architects. There was no division of "fine arts" from the "decorative." Uccello and Botticelli even made money by painting wedding chests for Florentine couples.

Painters were forced to use ancient architecture and sculpture as the basis of classical form because only fragments of painting had survived. It was not until the discovery of Nero's Golden House in Rome in the 1480s that artists such as Raphael could view the room-sized murals and life-like detail of Roman art.

Painters relied on their observation of underground grottoes and burial catacombs, which were decorated with grotesques and carved reliefs. There were also plenty of ancient coins and cameos in various Florentine art collections—Botticelli's *The Birth of Venus* was partly based on an ancient cameo belonging to the Medici family.

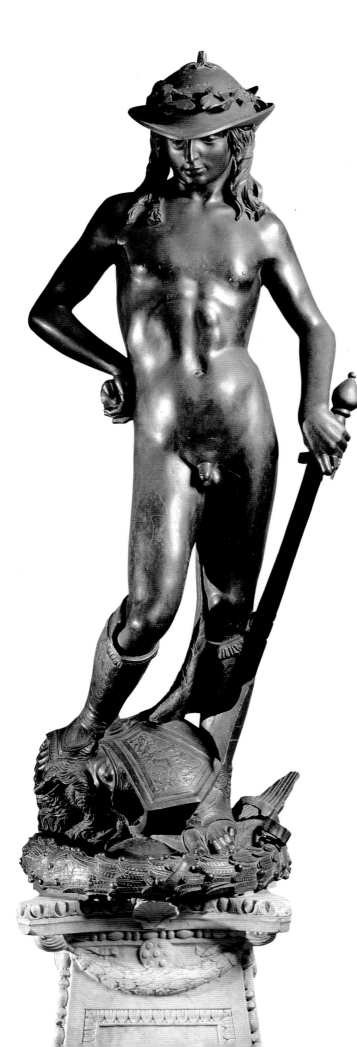

DONATELLO

One of Ghiberti's young assistants on the first set of Baptistery doors was Donato di Niccolo di Betto Bardi, known simply as Donatello. Donatello was fascinated not merely by the forms of antiquity and the optical qualities he could observe in the world but with the ability of the sculptor to express human experience. In his attempt to capture the inner life of his figures, his working style ranged from the ultra-realism of a penitent and downtrodden *Mary Magdalene* (1454–55) to an idealized version of *David* (c. 1440), the first free-standing nude statue since ancient times.

During the middle ages the nude was equated with original sin, and was usually seen only in representations of Adam and Eve. The acceptance of nude figures is considered to be one of the pivotal achievements in Renaissance art. Many of the poses of Early Renaissance nudes were copied directly from ancient sculpture, such as Mantegna's St. Sebastian, which has the perfect anatomy of a pagan god.

Donatello justified his innovative nude of David by citing the authority of antiquity, whose scholars and artisans considered the human body to be an ideal expression of beauty. Donatello was one of the first sculptors to grasp the key to the human stance as illustrated by classical sculpture: the figure's weight is placed on one leg with the other slightly cocked at the knee.

Donatello's male nude, however, was not based on a mythological god or Greek athlete—it was a completely original interpretation, remaining true to the biblical story by showing David as an adolescent boy.

David

DONATELLO, c. 1440; bronze. Bargello, Florence.
Donatello creates a striking and memorable impression by representing the young David in serene detachment from the horror implied by the enormous sword and the head of Goliath underfoot.

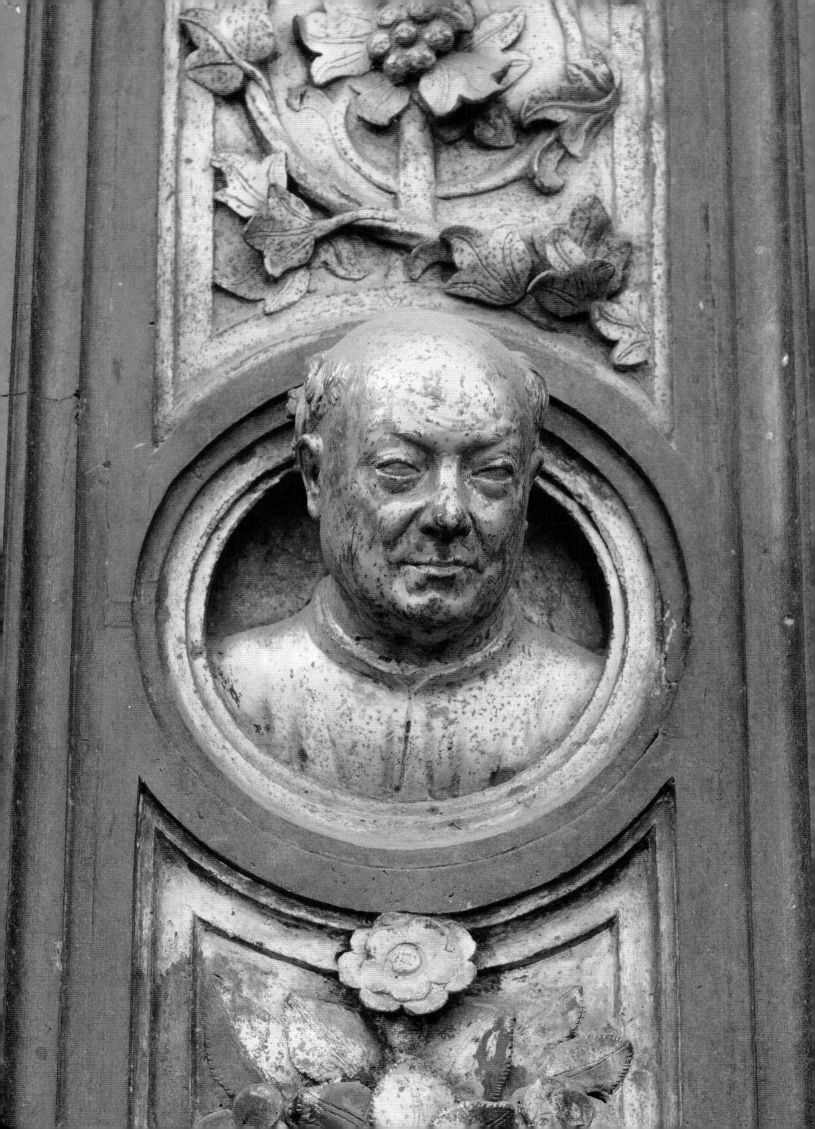

SCULPTURE

One of the first sculptural milestones marking the beginning of the Early Renaissance was the competition for the North Doors on the Baptistery of Florence Cathedral. According to Lorenzo Ghiberti's account, his panel easily beat those offered by scores of other artists, including Brunelleschi. The commission was highly profitable and the reliefs took over twenty years to complete (1403–24). When the North Doors were completed, Ghiberti was immediately awarded another commission for the East Doors of the Baptistery, which he worked on from 1425–52.

Ghiberti's sculptural reliefs on the two sets of Baptistery doors clearly show the transition from medieval conventions to the innovations of the Renaissance. In the first set of reliefs (North Doors), the figures are set on the same plane, relying on lines of folded drapery to create a sense of depth and motion. The tableaus are contained within quatrefoil frames that lend the same effect as the border on a manuscript illustration.

In the second set of doors (East Doors), each scene from the Old Testament fills the entire panel. The space is rendered in a convincing manner, and the illusion of depth is effectively created by Ghiberti in his use of pictorial perspective. The architecturally sound structures recede into the distance with the relief gradually becoming a lightly etched line in the background.

Though the figures are arrayed in a frieze-like row in the foreground, they pose naturally with lifelike gestures, and their sculptural roundness creates an astonishing sensation of depth. Ghiberti based the anatomy on his extensive collection of ancient sculpture, bronzes, and coins gathered through his long career. His reliefs were only the beginning of a new realism inspired by the study of man and nature.

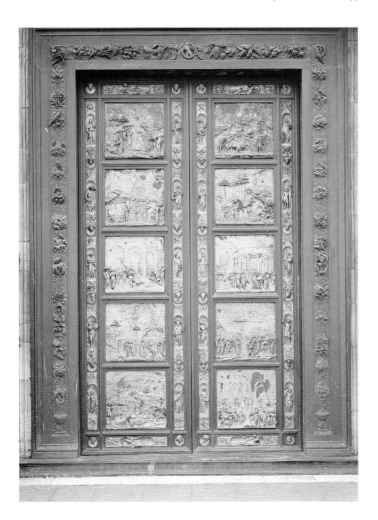

The Gates of Paradise
(East Doors of the Baptistery)

LORENZO GHIBERTI, 1425–52; gilded bronze. Baptistery, Florence.
Ghiberti was deeply influenced by Alberti's theories (espoused in his *De Pictura* [*On Painting*], 1435) when he designed these doors. When Michelangelo said they were worthy to be the gates of Paradise, the nickname stuck.

Self-Portrait

LORENZO GHIBERTI, 1425–52; from Gates of Paradise (East Doors of the Baptistery); gilded bronze. Baptistery, Florence.
Ghiberti's self-portrait in one of the small medallions on the doors represents the transition from the middle ages to the Renaissance. Here, Ghiberti renders himself as a humble artisan of the middle ages, yet his pride on winning the coveted commission for the Baptistery doors is thoroughly Renaissance in its self-congratulation.

(*De architectura*) and was inspired by Vitruvius's anthropomorphic descriptions of classical forms which characterized the plain strength of the Doric column as "masculine," while the Ionic was "feminine" in its slender grace.

Alberti wrote a number of important theoretical works on art and architecture (*Della pittura*, 1436, and *De re aedificatoria libri X*, 1452) in which he urged artists to chose subjects based on ancient literature and models. He drew his examples from the descriptions first lauded by Pliny in his *Natural History*.

In the preface of *Della pittura*, Alberti raved about the new dome that was being erected over Florence Cathedral, and he proclaimed that Brunelleschi's dome outdid antiquity. Alberti believed that the benefits of modern technology enabled artists not only to rival classical perfection but improve upon it. Alberti's key contribution was his own system of deploying classical elements, and his popular architectural designs epitomized the Renaissance tendency to adapt and transform classical motifs.

It was common in that day to simply build a new façade to refurbish existing structures. Alberti's façade for the Palazzo Rucellai in Florence (c. 1450s) unified a group of three medieval-style houses. Based on Vitruvius's treatise, Alberti used a different classical order of columns for each story: Tuscan (an adaptation of the Doric order) for the ground floor, Ionic (with the addition of acanthus leaves usually seen in Corinthian) for the second floor, and pure Corinthian on the third floor.

The demands of classical proportions sometimes clashed with the needs of the Church. Architects from the early decades of the Renaissance, such as Brunelleschi and Alberti, to Mannerist architects Michelangelo and Vasari all designed plans for centrally harmonious churches. But the clergy was insistent in their demands for a traditional cross-shaped church because it was more practical for Christian religious services.

When Alberti designed Sant' Andrea in Mantua (1470), he retained the elongated nave but refused to compromise on the façade. The temple pediment is supported by four huge pilasters and a triumphal arch, forming a façade that is markedly shorter than the rest of the basilica.

Façade, Santa Maria Novella

LEON BATTISTA ALBERTI, c. 1456–70. Florence.
In this grand façade, Alberti combined classical pediments (attached columns) with the form of a Roman triumphal arch. The scroll-buttresses accent the centrally balanced design.

Nave, Sant' Andrea

LEON BATTISTA ALBERTI, 1470. Mantua.
Alberti decided to omit the medieval colonnades of the nave, leaving the space a vast open hall. The deep coffers in the vaults are also reminiscent of the dense enclosing masses of Roman architecture.

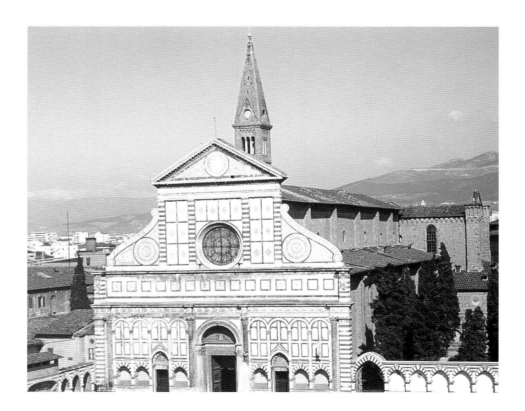

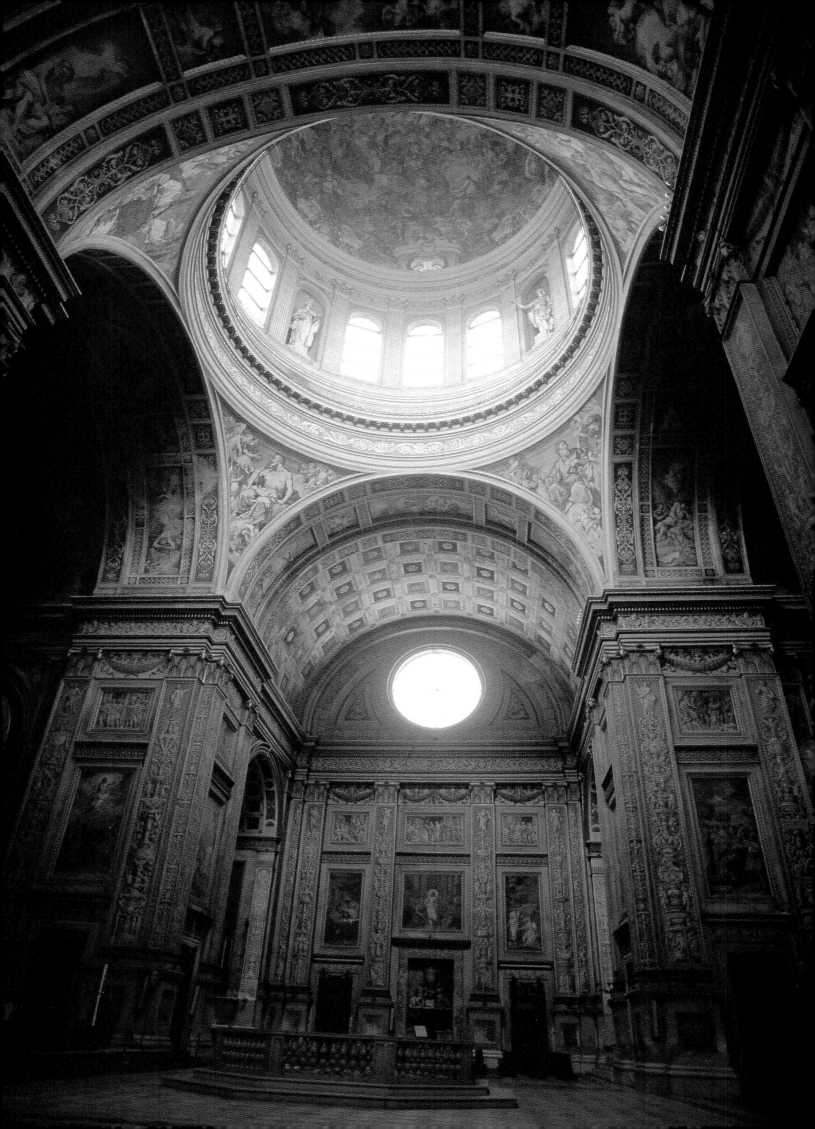

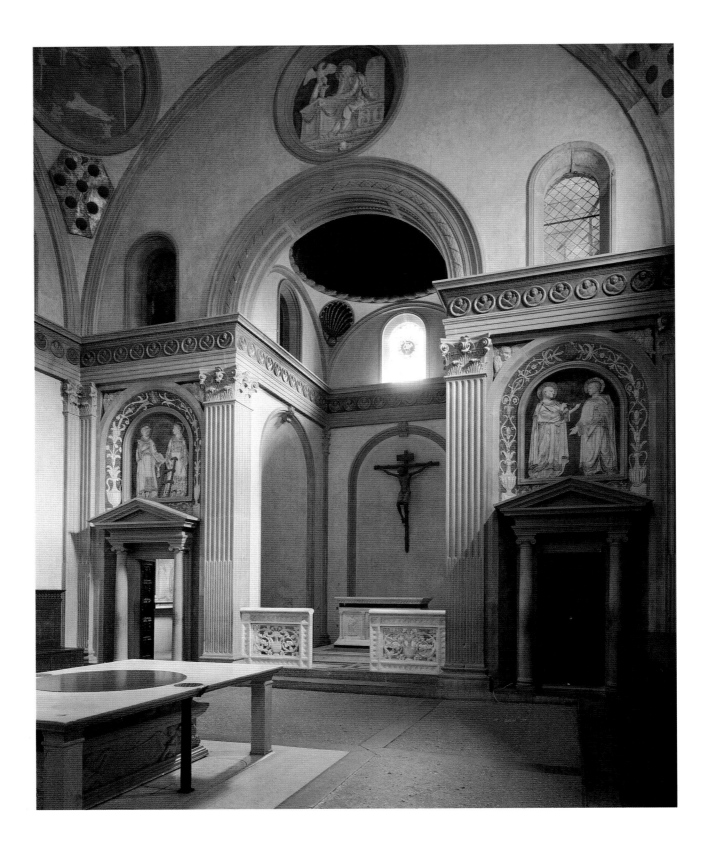

The Old Sacristy

Filippo Brunelleschi, 1421–28. San Lorenzo, Florence.

The interior of Brunelleschi's structures are mathematically proportioned at 2:1, according to classical theory. With the cool, clear light to illuminate shadows and moldings, the interior expresses the Renaissance faith in reason rather than emotion.

The Palazzo Rucellai

LEON BATTISTA ALBERTI, 1446–51. Florence.

Italian merchants and noblemen built grand palazzos to show off their wealth and power. Not since the Romans had so much time, effort, and money gone into the design of private, urban dwellings.

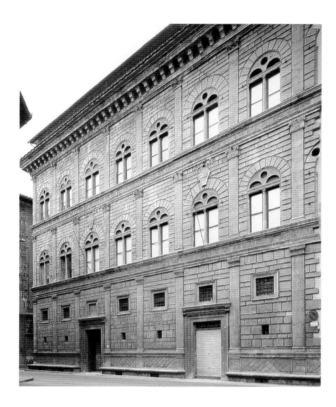

dome, and no architect was able to design a structure that could cross the seemingly insurmountable distance of 140 feet (43 meters).

In 1417 Brunelleschi was hired as an adviser to the Florentine Board of Works (Opera del Duomo) to create a masonry model of the dome. Though Brunelleschi was inspired by the breadth of the hemispherical dome of the Pantheon, the model that was accepted in 1420 had more resemblance to the Baptistery of Florence, an early medieval structure that architects had erroneously believed to be ancient.

To solve the construction problem, Brunelleschi designed the dome to have two shells. The outer dome is joined to the interior one by their common ribbing, and a stairway between the shells served as scaffolding for the construction of the outer dome. The smaller, inner dome is thick and carries most of the weight of the outer one. This was necessary because the walls of

the drum, the base of the dome, had already been built without buttressing—the support structures which enabled architects to build towering Gothic cathedrals. From the inside, the inner dome appears to be rather pointed and Gothic, while the exterior view suggests a vast open space contained inside.

As work began on the construction of the Cathedral dome, Giovanni de' Medici bestowed one of his first major commissions on Brunelleschi. The Old Sacristy of San Lorenzo (1421–28) was intended to be a chapel for the Medici family and the site of Giovanni's tomb. The square building is attached to the Basilica of San Lorenzo, and is called the Old Sacristy to distinguish it from the "New" Sacristy which was later designed by Michelangelo to house the tombs of Giuliano and Lorenzo de' Medici.

Brunelleschi's work on the revolutionary architectural space of the Old Sacristy soon led to a commission (subsidized by the Medici family) to rebuild the nave and choir of the basilica of San Lorenzo. Brunelleschi once again combined ancient and Romanesque forms, retaining the traditional basilica plan that early Christians had adopted for their religious rites. Thus the floor plan is in the shape of a cross, with a long nave crossed near the altar by the transept.

Brunelleschi's cool, harmonious design was deliberately lacking in interior decoration, giving it an effect of grand elegance. Unlike medieval buildings there is no stained glass, allowing pure light to enter through the round clerestory windows. Brunelleschi intended the focus to be on the space and structure rather than on the decorative murals and ornate sculpture, as with Gothic cathedrals.

In one area Brunelleschi was not very successful. He was never hired to design the grand palaces that were springing up all over Florence in the 1430s and 1440s. He did submit a model for the new palace that Cosimo de' Medici was commissioning, but his design was rejected as too grand and imposing in the face of the "democratic" Florentines.

LEON BATTISTA ALBERTI

Alberti was a writer, sculptor, and painter as well as a fabulously successful architect in his own day. He was the first to seriously study the treatise of Vitruvius

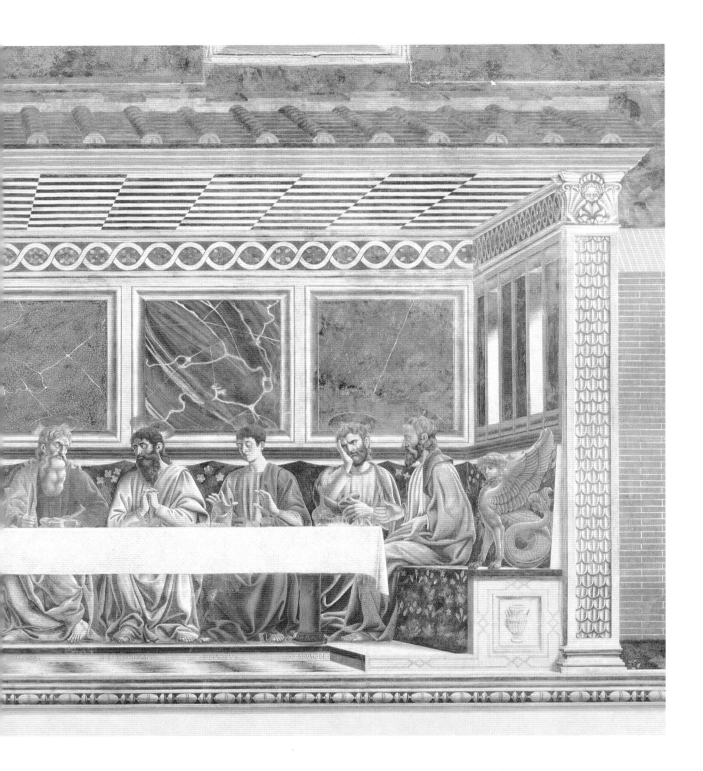

The Last Supper

ANDREA DEL CASTAGNO, 1447; fresco. Refractory wall of Sant' Apollonia, Florence.

The scene of the Last Supper was often depicted on the walls of the refractory (dining room) in monasteries. Here, Castagno paints the illusion of the room continuing into space, as if the Last Supper was actually taking place alongside the monks.

(a downtrodden Clement VII agreed to crown Charles V Holy Roman Emperor barely three years after the Sack).

One of the most prominent patrons of the High Renaissance was Pope Leo X, son of Lorenzo the Magnificent. Lorenzo the Magnificent, grandson of Cosimo de' Medici, took public works to a new height. Lorenzo established the Platonic Academy of Philosophy, and spent vast sums on buildings and festivals to gain the affection of the Florentine people. He also revitalized the academy of art instruction which influenced centuries of European artists. Since the artisan guild in Florence was a loose business association rather than a strict union, the artists of the Early Renaissance had unprecedented freedom to experiment with new forms of expression.

Architecture

In 1401 two young Florentine artists, Filippo Brunelleschi and Donatello, traveled to Rome to study the ancient monuments. They drew and measured every piece of antiquity they could find, including the Pantheon which inspired Brunelleschi's design for the immense dome of Florence Cathedral. The two artists also directly observed the forms of Doric, Ionic, and Corinthian styles that they would later compare to Vitruvius's descriptions in *De architectura*.

Brunelleschi developed the technique of linear perspective out of the need for accuracy in his drawings. It was not merely the appearance of the ruins, such as the ratio between the parts, but their structure and the support systems he wanted to record. In order to engineer his own buildings, he had to be certain that his measurements and plans were accurate.

Linear perspective allowed Brunelleschi to reproduce exactly what he saw. The technique established a scientific structure that artists could use to duplicate their observations of the physical world. When a room is viewed from a fixed standpoint, all of the lines that indicate depth (those that seem to recede into the distance) are set at an angle that makes them seem to meet eventually in a single point on the horizon. In order to create the perfect illusion of an interior or a round dome, a single vanishing point can be chosen, and as long as the vertical lines are absolutely parallel, the perspective will be perfect.

By thoroughly mastering the designs of ancient structures, Brunelleschi was able to improve upon the originals. New engineering methods made it possible to combine forms and motifs in ways the ancients could not. Brunelleschi used his knowledge of classical forms to solve the decades-old problem of constructing the dome for Florence Cathedral. By 1400 the Cathedral had been completed except for the

The Dome of Florence Cathedral

Filippo Brunelleschi, 1420–36; plan by Arnolfo di Cambio, 1296; lantern completed late fifteenth century. Florence. Brunelleschi's octagonal dome, shown here in an early engraving as well as a modern photograph, was the largest built in Western Europe since the Pantheon. The unique herringbone pattern of the bricks carries the enormous weight away from the structural supports of the ribbing, while the lantern at the top weights the dome, holding the ribs together.

THE EARLY RENAISSANCE

View of Florence

S. BUONSIGNORI, c. 1480; copy of the Carta della Catena.

Museo di Firenze com'era, Florence.

This view of Florence depicts the walls of the city

protecting the bridges over the Arno. Florence

Cathedral is the dominant structure in the center of town.

During the Early Renaissance, Florence was the intellectual and artistic capital of Europe. The Italian peninsula was seeped in antiquity, with ruins of Roman structures and monuments testifying to the strength and grandeur of classical forms. Along with famous artists such as Leonardo da Vinci and Michelangelo, some of the more renowned citizens of Florence were Dante, Machiavelli, Galileo, and Amerigo Vespucci (who gave his name to the Western continents).

Florence was founded around the first century B.C. as a colony for Roman soldiers. The garrison was intended to protect the only practical north-south crossing of the Arno River. It is situated in the center of Italy, surrounded by the vineyards and orchards of the rolling hills of Tuscany.

By 1197 the Tuscan League controlled Florence, one of several powerful city-states in Italy that had established their territorial bounds by successful conquest of neighboring lands. Florence was economically the most prosperous city in Italy, with Florentine bankers the leading creditors not only for their own countrymen but all of Europe.

Though politically Florence was considered to be a democracy, the Medici family dominated the city. Giovanni de' Medici was elected chief arbiter in 1421, and his son Cosimo shrewdly utilized their banking empire to gain unofficial sovereignty over Florence. Eventually one of Cosimo's younger sons, Lorenzo de' Medici, founded the grand-ducal line.

Like the aristocracy of Milan, Ferrara, and Mantua, the Medici did not rule by the strength of armies but by their financial power. Giovanni began the tradition of magnanimous patronage, donating grand and beneficial works to a grateful people to reinforce the family's popularity.

The Medici family was so powerful that the popes relied on their support to maintain the ascendancy of the Church. Several of the Medici's became popes, including the unscrupulous Alexander VI, who ruled in the 1490s, and Pope Clement VII, who endured the Sack of Rome by Habsburg forces in 1527

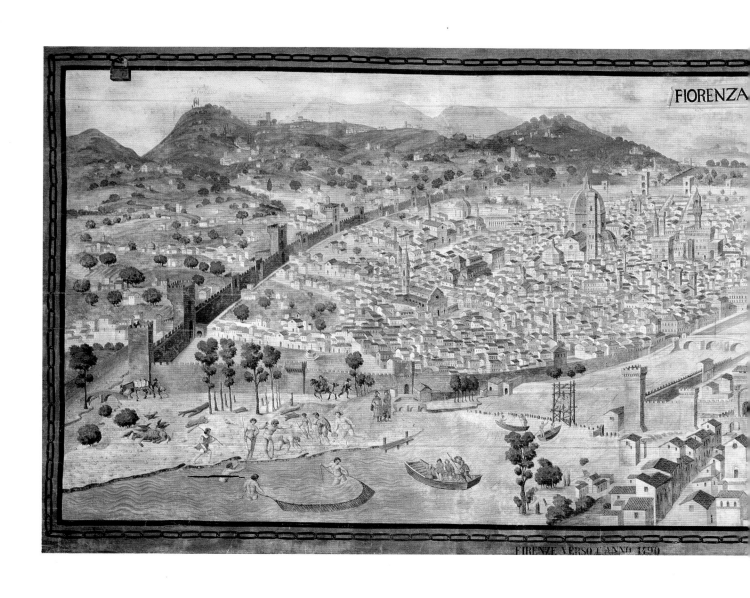

FIORENZA

FIRENZE VERSO L'ANNO 1490

20

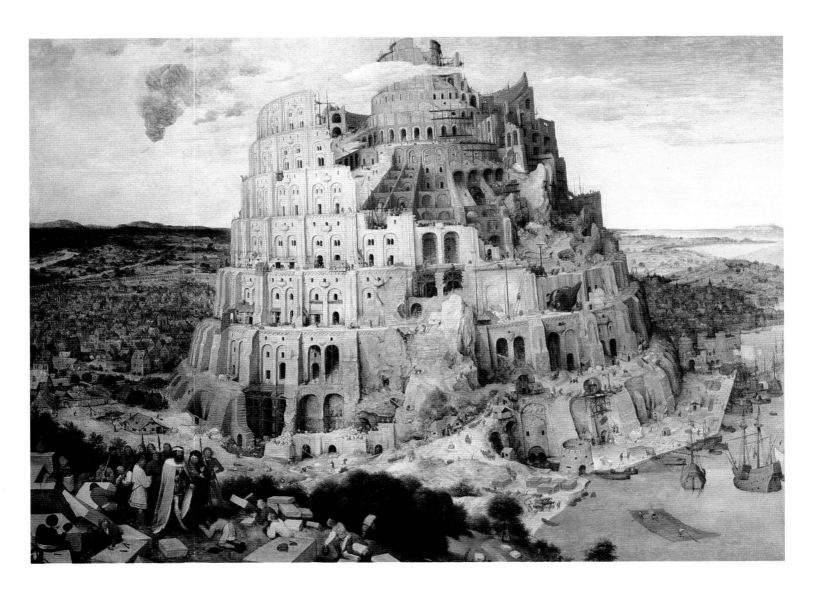

The Tower of Babel

PIETER BRUEGEL THE ELDER, 1563; oil on panel; Kunsthistorisches Museum, Vienna.

Bruegel used the Colosseum as the model for his

Tower of Babel, theorizing that with such a sound architectural

basis, a tower could be built to reach into the clouds.

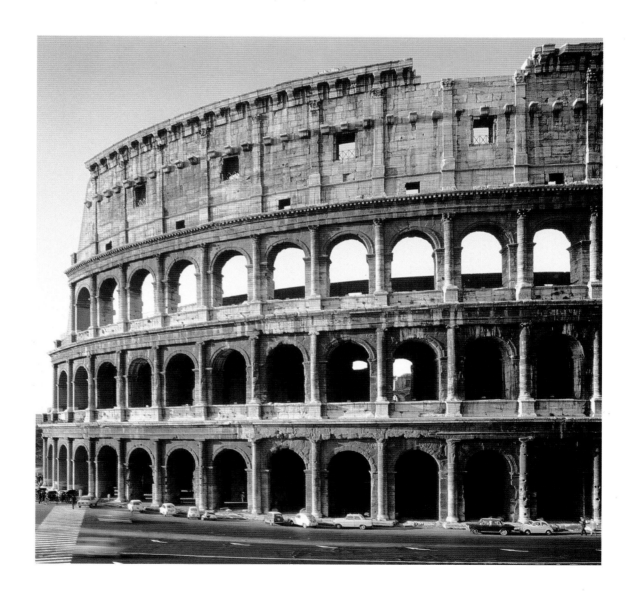

The Colosseum

A.D. 70–82; concrete. Rome.

The Colosseum is the largest and best preserved Roman monument, proving that the Romans were masters of practical architecture. The terraced seating allowed fifty thousand spectators to view the games, while below ground level there was a maze of holding rooms for athletes, prisoners, and animals.

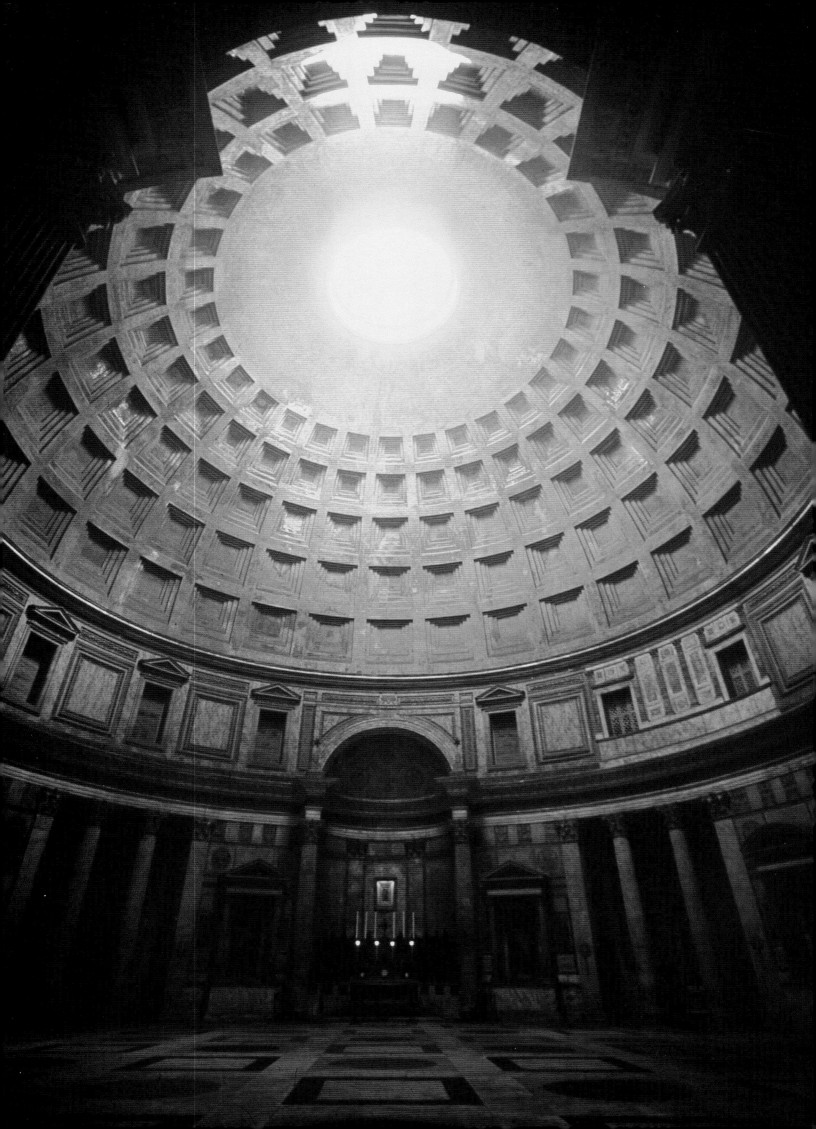

spheres, on flat surfaces. This meant an artist could realistically render anything at any angle, whether it was a person's head or the interior of a room.

Not only were visual perceptions changing, but people were experiencing a more complex view of time as a result of the increasingly commonplace existence of clocks. Urban life was enhanced by mechanical devices such as hydraulic systems that pumped water into fountains to provide a fresh and constant supply for city residents. Renaissance science also gave the world gunpowder, which transformed combat from hand-to-hand battle into long-distance killing with projectile weapons.

The compass and new kinds of ships were invented, promoting the discovery of the western continents and worldwide exploration. After 1492, scholars were priding themselves on the fact that the ancients had been ignorant of the so-called new world, proving that the Renaissance was not simply a revival but an improvement on ancient ways.

By 1520, Ferdinand Magellan's ship had completed its sail around the world, opening new trade routes and bringing with him an influx of eastern ideas. The need for accurate navigation led to the search for more precise ways to observe the sky, and this culminated in the invention of the refracting telescope by Galileo in the late sixteenth century. In 1543 Copernicus published his revolutionary theory declaring that the center of our solar system was the sun and not the earth, as Scripture had dictated.

The principal technological discovery of the Renaissance was the printing press. The printing press gave a wider public access to both classical and contemporary knowledge. Intellectual thought in Europe was changed by the explosive spread of scientific drawings on anatomy, botany, zoology, engineering, and mechanical processes, allowing scholars to build on each other's investigations rather than having to start from scratch every time.

Printing first developed in the Rhineland in the mid-fifteenth century, and the new invention quickly spread throughout Europe. Printing on parchment using wood blocks had been developed in the middle ages, but the arrival of paper from the East (along with imports of Chinese silk and porcelain) led to the development of cheap manufacturing methods.

The first book that Johann Gutenberg's press in Mainz printed was the Bible (1455). For centuries the Bible had been the most reproduced text by monastery scriptoria, and the earliest style of printing copied the style of manuscript texts, with the margins decorated by hand.

From the 1460s on, books were printed in every part of Europe. Religious books continued to be the most numerous, along with the Greek and Latin classics, as well as texts on practical and technological matters. Pliny's *Natural History* was first printed at this time.

Engravings were also made of ancient sculpture, architecture, and contemporary art. An engraving is a drawing incised on a metal plate. A print is made by inking the plate and pressing it against a sheet of paper. Many prints could be made from the same plate so this type of art was cheap and could be widely circulated. Italian prints had an important influence on northern painters, such as Albrecht Dürer, whose own prints still stand as masterpieces of the technique of engraving.

The printing press, which disseminated information faster than ever before, was also heralded as an achievement that proved the superiority of the Renaissance over antiquity. It is an ironic reversal that the ancient languages are now hardly printed except for University study, while reproductions of Renaissance masters can be meticulously produced, preserving these important works for generations to come.

The Pantheon

A.D. 118–125; marble. Rome.

Marble of every color was used to decorate the walls and floor of this circular temple in geometrical patterns. Wall niches formerly held statues of pagan deities, but during the middle ages they were turned into saints' shrines.

science and art, thus enabling the artists of the Renaissance to express the ideals of their age through masterpieces of architecture and the human figure.

TECHNOLOGY

The Renaissance was on the cusp of true science. It was a time when alchemy and astrology were pervasive, yet even these pseudo-sciences passed on benefits to modern man. Alchemy served to identify a vast number of chemicals, in spite of the fact that many alchemists did not fully understand how to effectively manipulate their materials. Astrology contributed a wealth of accurate observations of the heavens, even if the astrologers were not always able to make predictions through the movements of the stars.

Scholars combined the new methods of directly observing nature to find patterns and meaning, breaking things down in an attempt to analyze the inherent components. Renaissance advances in metallurgy, mechanics, navigation, and warfare changed the way humanity viewed the world at large.

In particular, the study of mathematics revolutionized art and architecture. Perspective and vanishing points were discovered, along with the technique of foreshortening which enabled artists to accurately represent three-dimensional objects, such as cubes and

St. Peter's

MICHELANGELO, 1546–64. Vatican, Rome.

Michelangelo was appointed by Pope Paul III to complete the dome according to Bramante's plans. The original shape of the dome echoed the hemisphere of the Pantheon, but engineering needs necessitated a shell that was somewhat elongated.

St. Peter's

MICHELANGELO, 1546–64. Vatican, Rome.
This early engraving shows a
cross-section of the dome and interior
of the celebrated St. Peter's basilica.

study of classical antiquity took him throughout Europe as he visited scholars and monastic libraries in his search for manuscripts. The Renaissance humanists, as opposed to the theologists, were interested in man and the qualities of human nature. Petrarch's texts and poems influenced art, literature, history, religious reformation, political systems, and even social manners.

During the Renaissance a money economy arose from the increase in intercontinental trade, establishing the basis for a temporal society. Merchants brought treasures of gold and foreign knowledge to the cities of Europe. Courts, which had long been the focus of government and administration, naturally became centers where scholars could go to find out more about the world.

Unlike the medieval universities that specialized in rhetoric, law, or medicine, a humanist education prepared the Renaissance man for life in the court and city. Humanist studies included lessons on poetry, music, philosophy, and history. Social dynamics and ethics were governed by rituals of manners and accomplishments (based on medieval notions of

chivalry) that had to be mastered as thoroughly as stanzas of classical poetry.

For the first time the individual gained unique importance. Class distinctions were shifting and those with merit or wealth could reach the top of the social hierarchy. A man could become great and powerful by possessing the divine gift of creativity. Philosophical debates over humanist values led to a belief that humans were intellectually capable of fine levels of discernment. Art became a mode of self-expression and discovery rather than a means of ornamentation. This can be seen in the rapid development of realistic portraiture as an independent genre.

The versatility of many Renaissance artists such as Alberti, Brunelleschi, Leonardo da Vinci, and Michelangelo led to innovation and experimentation not seen during the middle ages. Through patient, careful observation of the natural world, artists were able to develop mathematical systems (such as linear and atmospheric perspective), which was the origin of science.

The separation between science and the arts, philosophy and literature was not as seemingly clear-cut it is today. Mathematics and art went hand in hand, as did

included a full description of the renowned sculpture *Laocoön*.

Renaissance artists were inspired by Pliny's recountings. In particular, Leon Battista Alberti encouraged the idea of the artist as creator rather than mere technician. Alberti wrote a series of Latin works on subjects ranging from law and family to art and architecture. In 1436 *Della pittura* was circulated in manuscript form, and in 1452 he produced a counterpart to Vitruvius's book called *De re aedificatoria libri X* (*Ten Books on Architecture*).

As ancient forms of art and humanist learning were disseminated throughout Europe, contemporary art was created imitating these patterns. This included the use of forms found in pagan temples and triumphal arches that were often incorporated into designs for church façades and personal residences.

During the middle ages, art had served the needs of the Church. This tradition was continued during the Renaissance by legendary papal patrons and wealthy ecclesiastics who were associated with the papal court. In addition to hiring artists to create new structures and works of art, the popes encouraged the study of antiquity. In 1510, Julius II hired Bramante to build the Belvedere Courtyard in the Vatican so that artists could sketch the few pieces of ancient sculpture that had survived: the Apollo Belvedere, an ancient Roman copy of a fourth century B.C. Greek bronze, and the *Laocoön*, which was discovered in a Roman vineyard in 1506.

Secular rulers too required opulence and splendor to accentuate their position in Renaissance society, so they hired the services of the best artists and architects. In much the same way that the cities of Brussels, Antwerp, Prague, and Madrid owe their prestige to the power of the Habsburgs, the Medici were the patrons of Florence. In France, King Francis I had a collection of casts of ancient statues at Fontainebleau, and Albrecht V's Antiquarium in Munich was the home of northern Europe's first comprehensive collection of ancient statues and portrait busts.

Artists from Alberti to Holbein were called on by rulers to decorate elaborate works for state entries into foreign cities and costly pageants to celebrate weddings or festivals. Many of the ceremonial statues and triumphal arches completed during the Renaissance were never meant to stand. Henry VIII was so anxious to impress King Francis I that he employed thousands of people to construct an enormous, temporary palace for the meeting at the Field of Cloth of Gold (1520) near Calais.

Humanism

The Renaissance was an age of transition from the theological preoccupations of medieval feudalism to an age of secular materialism. The dogma of religion was challenged by the clergy itself when, in the thirteenth century, St. Francis of Assisi founded the influential Franciscan order. Franciscan friars spread throughout Europe teaching a version of Christianity which emphasized a reverence for the beauty of the world and the inherent goodness of living a simple, natural life.

Petrarch, the fourteenth-century Italian poet and scholar, was the first great humanist who formulated the Renaissance concept of individualism. Petrarch's

The Three Graces

c. 100 B.C.; marble. The Louvre, Paris.

This Hellenistic sculpture was well known during the Early Renaissance, a period when artists blatantly copied classical mythologic subjects and even exact figural poses out of veneration for Greek and Roman ideals.

manuscripts were given to the library of the Dominican house of S. Marco. Cosimo de' Medici paid much of Niccoli's debt to insure that the priceless manuscripts remained in Florence rather than being sold off and scattered across distant lands. And by 1475, Nicholas V had assembled in Rome the core of the Vatican Library, consisting of over 1,100 texts with nearly one third in Greek and the rest recent Latin translations.

These ancient works offered a great deal of theoretical information to European artists. Marcus Vitruvius Pollio's manuscript *De architectura* (first century B.C.) was discovered in 1415, and provided valuable descriptions of Greek and Hellenistic architecture, including the classical orders, city planning, and wall painting.

Medieval scholars knew about Vitruvius from Pliny the Elder, who cited Vitruvius as a source in *Natural History*, an encyclopedia of Greek science and history (*Historia naturalis*, A.D. 77). Pliny had compiled material by earlier authors into thirty-seven books which examined "the nature of things, that is, life." Along with books on astronomy, zoology, botany, and geography, Pliny examined the political history of the Greek city-states and provided biographical information on notable Greek scholars and artists. He even recorded works by the ancient Greek artists Phidias and Apelles, and

The Rape of the Sabine Woman

GIOVANNI BOLOGNA, c. 1580; marble.

Loggia dei Lanzi, Florence.

Bologna directly copied figures from the illustrious antique sculpture *The Laocoön Group* in his crouching old man and in the way the woman twists as she reaches one arm into the sky. Typical of the Renaissance, Bologna improves upon the ancient composition, interlocking the figures on an axis to create a spiraling movement rather than using the coils of the snakes to link the figures.

The Laocoön Group

Late 2nd century B.C.; marble.

Vatican Museum, Rome.

According to Roman scholar Pliny the Elder, this sculpture was the finest in antiquity. Stylistically, it represents the late Roman tendency to replace the calm, stable, harmonious world of classicism with movement, tension, and emotion.

AN AGE OF CHANGE

Many modern scholars mark the fall of Constantinople in 1453 as the end of the middle ages. Constantinople had long nurtured a culture of Christianity and learning but when the Turks overran the city, refugees were driven west into Europe. Among these refugees were Greek scholars whose goal was to save their precious classical manuscripts. These Greek scholars survived by teaching classical theories to European scholars, and they passed along their knowledge of the Greek language, enabling Europeans to translate the ancient texts for themselves.

Ancient Manuscripts

Books were treasured rarities in the early fifteenth century. Monastic schools only allowed their manuscripts to be read or copied within the monks' scriptoria. Privately endowed scholars had to travel to centers of learning and laboriously copy each text for their own libraries. Students were taught through lectures rather than individual study, establishing the foundations of the current University system.

Even before the fall of Constantinople, a classical revival was begun by the return of the papacy to Rome after a string of French popes underwent an extended residence in Avignon. From 1378 to 1417, during the Great Schism within the Roman Catholic Church, a series of important church councils were held to settle the rival claims of popes and various factions. These councils drew men of learning from all parts of Europe and they provided valuable opportunities for scholars to examine the collections of manuscripts in monastic libraries throughout Italy and southern France.

Cosimo de' Medici participated in the Council of Constance (1414–18)—which ended the schism—as the representative of the Medici bank, in charge of managing the Council's finances. Soon thereafter Cosimo began to manage all of the papacy's investments, and branches of the Medici bank were established in every large city in Europe.

It was during the years of the Council of Constance that Cosimo began a lifelong devotion to searching for classical books. Cosimo was such an avid collector of manuscripts that he once ordered two hundred volumes at the same time, despite the fact that it was extremely expensive and laborious to hand-copy the texts. It took two years for forty-five scribes to complete the task, and all costs were paid by the Medici bank. Cosimo de' Medici's humanist library in Florence was one of the largest private collections during the fifteenth century, and in the spirit of civic munificence it was open to the public.

Another Florentine scholar, Niccolo Niccoli, gathered a vast collection of ancient art objects and a library of classical texts (many had been copied by Niccoli himself). Scholars from across Europe visited Italy to see Niccoli's collection, and upon his death the

FOLLOWING PAGE:

The Crucifixion

detail; JAN VAN EYCK, c. 1420–25; canvas transferred from panel;
22¼ x 7¾ in. (56.5 x 19.6 cm). Museum of Fine Arts, Budapest.
The development of landscape painting as an independent genre was first seen during the Renaissance—a result of man's mortal, more earthly focus. Here, even the temple is crowded by the city of Jerusalem and its protective, turreted walls.

Primavera

Sandro Botticelli, c. 1478; tempera on panel;

6 ft. 8 in. x 10 ft. 4 in. (203.2 x 314.9 cm). Uffizi Gallery, Florence.

In this painting, the main figure of Flora is attended by

Botticelli's version of the three Graces. The three Graces

can also be seen in Francesco del Cossa's *The Triumph*

of Venus (1470), and on the reverse side of Niccolo

Fiorentino's medal of Giovanna Tornabuoni (1486).

Introduction

The Renaissance was a period of cultural growth that began in Italy and spread throughout northern Europe, lasting from approximately 1400 to 1600. Traditionally the Renaissance is considered to be the beginning of the modern age; the thousand years between antiquity and the Renaissance is thus popularly known as the middle ages, or the medieval period.

The Italian word for Renaissance ("*rinascimento*") means "revival." The scholars and artists of the Renaissance believed they were participating in a rebirth of the ideals and values of the classical Greek, Hellenistic, and Roman eras (lasting from 500 B.C. to A.D. 330, when Constantine moved the capital of the Roman Empire to the Greek city of Byzantium).

Renaissance scholars admired the philosophy, art, and literature of the ancient Greeks and Romans, rejecting the values and stylized conventions of medieval Gothic and Byzantine forms. Instead of relying on decorative lines and color to glorify scriptural stories and icons, the artists of the Renaissance rediscovered the importance of individual will and the necessity of observing nature in order to express drama and emotion in human terms.

As artists mastered the knowledge of antiquity, they began to improve on the surviving artifacts, taking full responsibility for their creations. Renaissance humanism was nurtured by political and economic changes such as the growth of urban society, the interconnectedness of trading nations, and the printing press, which gave the average man access to works of philosophy, literature, and art.

For the purposes of this book, the Renaissance has been divided into four periods: the Early Renaissance (roughly 1400–1495), the Northern Renaissance (1400–1525), the Italian High Renaissance (1495–1520), and Mannerism (1520–1600). Each of these periods is distinct in style and content, following the development of humanism in Western Europe.

The Loggia of the Farnese Palace

RAPHAEL and assistants, 1518–19; ceiling fresco. Farnese Palace, Rome.
Interior decoration changed during the Renaissance through the influence of newly discovered Roman wall decorations. Raphael was inspired by the rooms of Nero's "Golden House," which had been recently excavated from the grottoes.

Contents

Fax: (888) 719-7723
e-mail: info@newlinebooks.com

Printed and bound in Singapore

ISBN 1-59764-142-1

Visit us on the web!
www.newlinebooks.com

Author: Susan Wright

Publisher: Robert M. Tod
Editorial Director: Elizabeth Loonan
Book Designer: Mark Weinberg
Senior Editor: Cynthia Sternau
Project Editor: Ann Kirby
Photo Editor: Edward Douglas
Picture Reseachers: Heather Weigel, Laura Wyss
Production Coordinator: Jay Weiser
Desktop Associate: Paul Kachur
Typesetting: Command-O

†HE
Renaissance

MASTERPIECES OF ART AND ARCHITECTURE

SUSAN WRIGHT

NEW LINE BOOKS